IMAGES
of America

NASHVILLE'S SYLVAN PARK

IMAGES
of America

NASHVILLE'S
SYLVAN PARK

Yvonne Eaves and Doug Eckert

ARCADIA
PUBLISHING

Copyright © 2011 by Yvonne Eaves and Doug Eckert
ISBN 978-0-7385-8686-1

Published by Arcadia Publishing
Charleston, South Carolina

Printed in the United States of America

Library of Congress Control Number: 2010933369

For all general information, please contact Arcadia Publishing:
Telephone 843-853-2070
Fax 843-853-0044
E-mail sales@arcadiapublishing.com
For customer service and orders:
Toll-Free 1-888-313-2665

Visit us on the Internet at www.arcadiapublishing.com

*To Sarah Foster Kelley, whose research of and dedication to
the history of West Nashville remains unsurpassed.*

CONTENTS

ACKNOWLEDGMENTS

We would like to acknowledge the following people for their contributions to this book. Photographs, materials, recollections and/or production assistance were provided by Marjorie Gann Akin, Barry Burnette, Butch Bryant, Bud Campbell, Ed Crump, John and Jo Dean, Cindy Eckert, Jim Forte, John Geny, Jackson and Marjorie Grizzard, Fred Hatchett, Donald Harris, June Hedge, McGarvey Ice, Carol Kaplan, Beth Kindig, Mark Lambert, Frank Lampley, Dalton Lauderback, Jack Masters, Bernard Pickney, Connie Sadler Putman, Rob Stack, Mary Lane Stain, Sandra Bailey Vaught, and Connie Williams.

We would also like to thank the Disciples of Christ Historical Society; Park Avenue Baptist Church; All Saint's Episcopal Church; Kim Cherry at St. Ann's Catholic Church; Ann Cheadle and Sarah Graves at Sylvan Park School; the Cohn High School Alumni Association; John Broster, Suzanne Hoyal, Mark Norton, and Michael Moore of the State of Tennessee Division of Archaeology; Beth Odle at the Nashville Room at the Metro Nashville Public Library; the Tennessee State Library and Archives; the West Nashville Founder's Museum, and Debie Oeser Cox and the Metro Nashville Archives.

Unless otherwise noted, all images are from the collection of Sarah Foster Kelley.

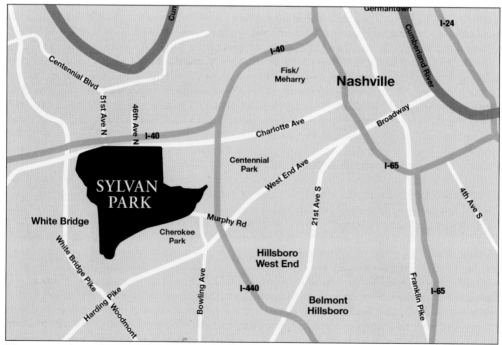

The current boundaries of the Sylvan Park neighborhood, largely unchanged over the years, are shown above. (Graphic by Sylvan Park resident Beth Kindig.)

INTRODUCTION

Epitomized in concise verbiage, the story of the foundation and development of West Nashville is romantic and interesting.

—Henry Francis Beaumont,
Written in 1908 for a real estate company that developed Sylvan Park

To call it a romantic history may be a stretch, but it is true the west Nashville neighborhood of Sylvan Park has an interesting history at the very least. Its turn-of-the-century development as a residential area began as both a retreat and a fresh start from sooty downtown Nashville. Ironically, its most recent popularity is due in some measure to it now being considered a conveniently close inner-city neighborhood.

The first inhabitants of the area, and of middle Tennessee in general, were early Native Americans who lived there for hundreds of years, leaving earthen mounds and arrowheads behind when they left the region about 1,000 ago. At one point, their population in Sylvan Park and the west Nashville area is believed to have numbered in the thousands.

The first of the "modern Native Americans" to come to middle Tennessee are believed to be the Shawnee Indians, who settled in the mid-1400s along the Cumberland River near what is now Metro Center, then the site of a large salt lick. It was called a "lick" because game animals in search of salt would lick the residue on the ground. The Shawnee tribe battled with the Chickasaw, Creek, and Cherokee tribes over the fine hunting grounds created by the animals attracted to this salt lick.

In 1779, as the leader of the first group of settlers to come to the wilderness that would later become Nashville, James Robertson could have chosen anywhere to make his home. As one of the first men of European background to ever see these lands, he reviewed a broad swath of territory and it was the "rich land" —as he stated—of the Sylvan Park area that caught his eye. It was the soil, abundant water, game, and hardwood forests that led him to lay claim there and build his home nearby. Charlotte Pike, named after Robertson's wife, was the path he traveled between the Nashville settlement and his home. He lost both a brother, Mark, and a son, Peyton, to Native American attacks along Richland Creek.

By 1796, with the admittance of the new state of Tennessee into the Union, the Nashville pioneers had clearly established both themselves and a significant measure of peace with the Native Americans. The number of residents and the amount of farming in the area increased. Crops and domestic animals added to the rural nature of the place that would one day be Sylvan Park. For a period of time, Richland Creek was referred to as the "western edge of civilization." Horses, cattle, pigs, and chickens were commonplace, as farms in this area raised their own produce, dairy, and meat products.

During the early 1800s, five plantations owned land in the area that later became Sylvan Park. Three plantations had their homes in the area. The Stump home was located near present-day Forty-second and Park Avenues. The large Byrd Douglas plantation home was at the current junction of Fifty-first Avenue and Charlotte Pike, and the Hewlett Childress plantation sat at the Richland Creek side of the current junction of Fifty-first and Wyoming Avenues. Although their mansions were located elsewhere, the Bosley and Elliston plantation grounds also reached into the area now known as Sylvan Park.

When the Union army captured Nashville in 1862, it was plantations like these that suffered the predatory hunger of tens of thousands of Federal troops. These men could not be safely denied as they passed through in need of not just food but horses, clothing, shoes, and medicines. Unfortunately in some cases, vandalism and thefts were perpetrated against those known to be Southern sympathizers. The Stump Plantation suffered looting and ill usage because of its owner's Confederate leanings. The head of another Sylvan Park household buried all the family valuables to avoid Union confiscation, then later died before he could confess to relatives near which sycamore tree he had buried the treasures.

Nashville's population skyrocketed with the Union occupation and continued to balloon after the war, from roughly 17,000 in 1860 to more than 80,000 in 1900. Downtown Nashville's streets and water and sewer systems were not ready for the demands. Wintertime coal use created so much dusty smoke that office workers who could afford it used two white shirts a day, donning one in the morning and changing to another in the afternoon. Residents increasingly looked for unspoiled spots for picnic getaways. With its relatively easy access via either Charlotte Pike or a small railway, the Sylvan Park area became one of the more popular of these retreats.

In 1887, a few enterprising businessmen sought to capitalize on the area's "getaway" attraction by beginning a land development. Opened with the flourish of cannon fire and a brass band playing, New Town was intended as a fresh start, a place where everything needed would be close by: homes, workplaces, supplies, and a sense of community.

New businesses were founded, new churches were granted land for the price of $1, and new schools were built. Residences were built that collected and stored their own rainwater—usually in large brick cisterns buried to the side or rear of the house, though in one case the cistern was located in the attic. The first homes in Sylvan Park were upscale residences built to attract the doctors, lawyers, and business owners of the day.

Lots were divided by streets that were first named numerically, then later renamed after the states from which developers hoped to draw residents: Nevada, Wyoming, Dakota, Idaho, and so on. Elkins Avenue somehow maintained the name associated with an important family that lived on the 3800 block. Park Avenue was the thoroughfare that ran next to the common area of Richland Park, which is presently the oldest Nashville park in its originally planned state. Richland Park was located on land originally used as a private deer park. When it opened, the surrounding area was still so rural that the fence around it was needed to keep the cows outside of the park grounds.

The planners considered government as well. A new West Town Courthouse was built at the Charlotte Pike end of what is now Forty-fifth Avenue, the current site of a U.S. Post Office. The Exchange Building served as a meeting area and an incubator for both business and religious organizations.

Developers trumpeted New Town, also called West Town, as a "Metropolis of Manufacturing." Hardwood flooring, cotton mills, and chemical and fertilizer factories were some of the early industries. Unfortunately, more than a dozen of these new companies, many set along the nearby Cumberland River for accessibility, failed during the Panic of 1893, the country's biggest economic downturn until the Great Depression. West Nashville's main investor and promoter, Dr. H. M. Pierce, was financially ruined by the collapse. He resigned his post and left the city.

New leaders stepped in and raised needed cash by selling large tracts of land—some was purchased by the state for a new penitentiary—and worked thereafter to make West Nashville a suburb rather than a separate entity. For decades afterwards, sirens would sound when a state prison escapee was on the loose, and likely the shine of exclusivity for West Nashville was somewhat lost.

The Sylvan Park name began with the Sylvan Park Land Company, organized in 1906 by Dr. J. E. Thompson and James A. Bowling. The builder of many homes in the area, Bowling called the home he built for himself Sylvan Park.

The Sylvan Park area was proud of its World War I soldiers and mourned their loss, but its greatest and most public tragedy happened near the war's end, on a hot July morning in 1918. On the area's southwestern boundary near Richland Creek and the present site of St. Thomas Hospital,

two passenger trains sharing the same track collided head-on at a combined speed of 110 miles an hour. The gruesome result remains one of the deadliest train wrecks in American history.

McConnell Airport, named for a National Guard pilot who died in1927 in a plane crash, opened that year on former farmland near Richland Creek. Sylvan Park children often watched flying lessons and daredevil stunts. Some of the first airmail ever delivered was sent from McConnell Field in 1928. McCabe Golf Course now operates on the site.

During the Great Depression of the early 1930s, larger homes in the area welcomed boarders. Destitute travelers on the nearby railroad or Charlotte Pike sometimes knocked on a Sylvan Park door to ask for work or food.

Like in other parts of the country, community cooperation shined during the 1940s and World War II. Today's older residents recall the paper drives, scrap drives, and long hours of bandage rolling that took place at Cohn High School. Twenty-five Cohn High students lost their lives serving in World War II. A water heater manufacturer in the neighborhood was retooled to produce bomb warheads. A local church obtained property and built small homes in the area to aid War World II veterans and widows. These homes were built with distinctive concrete block walls that, in today's times, are fashionably painted with southwestern colors.

The baby boom of the 1950s and the prosperity of the 1960s fueled a surge in Sylvan Park homes, churches, and businesses. The large areas between Sylvan Park residences disappeared as more houses were built, typically single-story homes or brick duplexes that were unlike the older Victorian residences.

Sylvan Park was and is a neighborhood in which people like to remain. It's not uncommon for some residents to have lived there their entire lives. Today Sylvan Park is a neighborhood in transition from older residents to new, considered politically aware and active, and has been cited as one of the fastest-rising property value areas in Nashville.

While this publication follows the chronological history of the area to include as many important locations and events as possible, it does not represent a scholarly effort. Instead it is intended to convey a sense of the longtime uniqueness and importance of the Sylvan Park neighborhood that have made it not uncommon for families to stay here for generations.

SYLVAN PARK

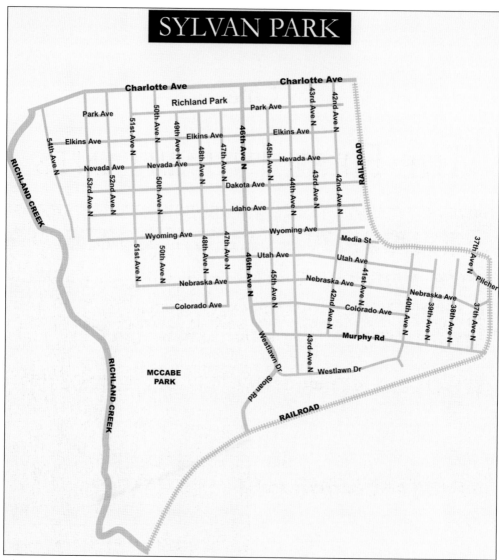

The streets and boundaries of Sylvan Park are given a closer view in the above map. (Courtesy of Sylvan Park resident Beth Kindig.)

One

THE FIRST INHABITANTS

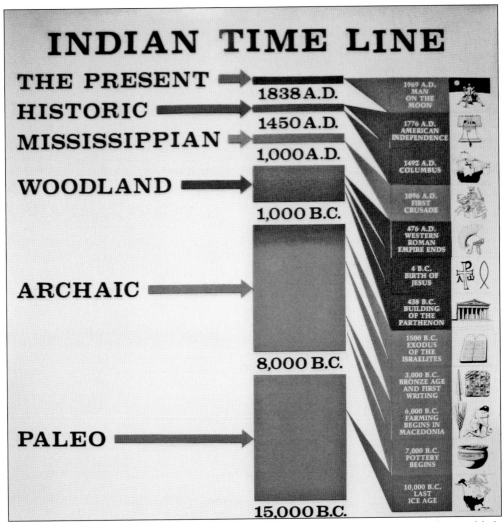

INDIAN TIME LINE

THE PRESENT ➡	1838 A.D.
HISTORIC ■ ➡	1450 A.D.
MISSISSIPPIAN ➡	1,000 A.D.
WOODLAND ➡	1,000 B.C.
ARCHAIC ➡	8,000 B.C.
PALEO ➡	15,000 B.C.

1969 A.D. MAN ON THE MOON

1776 A.D. AMERICAN INDEPENDENCE

1492 A.D. COLUMBUS

1096 A.D. FIRST CRUSADE

476 A.D. WESTERN ROMAN EMPIRE ENDS

4 B.C. BIRTH OF JESUS

438 B.C. BUILDING OF THE PARTHENON

1500 B.C. EXODUS OF THE ISRAELITES

3,000 B.C. BRONZE AGE AND FIRST WRITING

6,000 B.C. FARMING BEGINS IN MACEDONIA

7,000 B.C. POTTERY BEGINS

10,000 B.C. LAST ICE AGE

As the above time line shows, the first humans to hunt and gather in Sylvan Park most likely passed through the area several thousand years ago. The first inhabitants to build substantial housing probably came here more than 1,000 years ago, about 800 years before the first pioneer occupations. (Courtesy of Tennessee State Museum.)

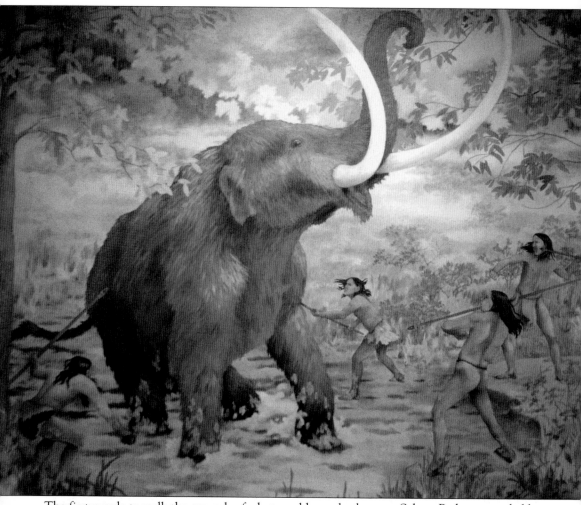

The first people to walk the grounds of what would one day become Sylvan Park were probably nomadic Ice Age hunters, in pursuit of large elephant-like creatures called mastodons. Imagine using a stone-pointed spear to hunt a short-trunked, curly-tusked elephant whose shoulder could reach up to 15 feet tall. (Courtesy of Tennessee State Museum.)

Seeing the size of Mastodon bones and tusks will make most anyone respect the early men who hunted them with spears and axes. At right are a mastodon jawbone and small tusk portion found in the Harpeth River and now on display at the Tennessee State Museum in the James K. Polk Building in downtown Nashville. A $1 bill is on the ledge for scale. (Courtesy of Tennessee State Museum; photograph by D. Eckert.)

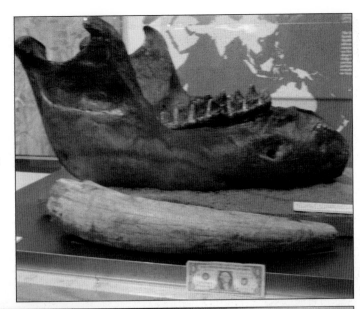

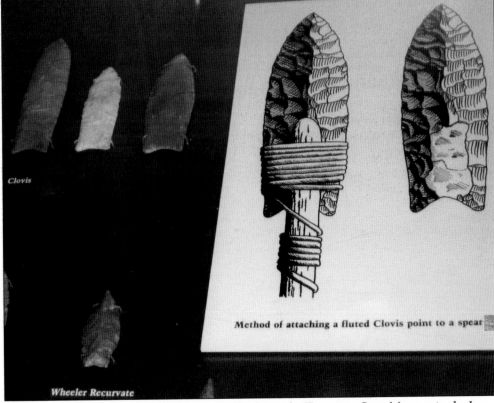

Clovis

Wheeler Recurvate

Method of attaching a fluted Clovis point to a spear

Above are symmetric fluted Clovis points on display at the Tennessee State Museum in the James K. Polk Building. It can't be stated with certainty such points were used in the Sylvan Park area, but they are typical of those used for mastodon hunting. With no known skills for growing crops or raising domesticated animals, these early hunters were tied to the migrations of the herds they depended on for food. (Courtesy of Tennessee State Museum; photograph by D. Eckert.)

TRANSITIONAL LATE ARCHAIC—EARLY WOODLAND
PROJECTILE POINTS
2000 B.C.-1000 B.C.

A Ledbetter
B Appalachian Stemmed
C St. Charles
D Wade
E Cotaco Creek
F Mulberry Creek

Above are the more common Native American arrowheads that young boys in middle Tennessee used to search for. The first long-term residents of the Sylvan Park area appeared a little more than 1,000 years ago. These Mississippian-era Native Americans had learned how to use bows, make pottery, and plant corn. These people left behind many of their implements and artistic creations in the stone box graves in which they buried their kin. (Courtesy of Tennessee State Museum; photograph by D. Eckert.)

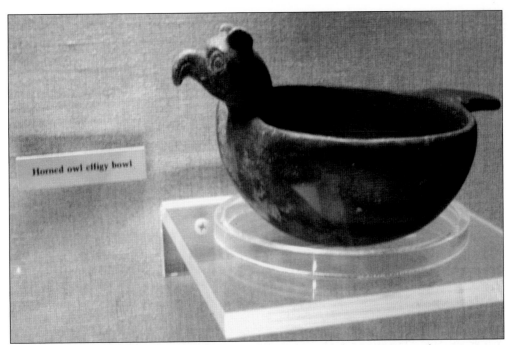

Less than 5 miles from Sylvan Park, a major cemetery of more than 3,000 stone box graves was found on what was known as the Noel Farm, near Granny White Pike and Clifton Lane. The site remains a major source for many of the surviving artifacts from the early Native Americans. Pictured above is a horned owl effigy bowl from the site. (Courtesy of Tennessee State Museum.)

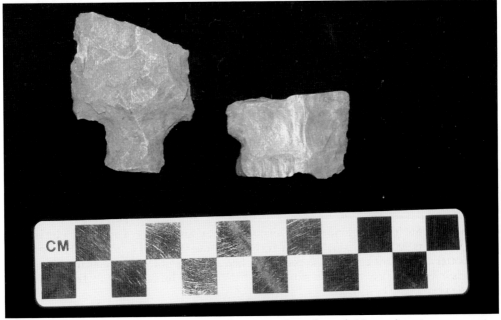

In this picture are the only known surviving flint points from the early Native American occupation of Sylvan Park. These two artifacts, found in 1993, are now stored at Pinson Mounds State Archaeological Park in west Tennessee. They have been classified as early Archaic, making them likely over 2,000 years old. (Courtesy of State of Tennessee Division of Archaeology.)

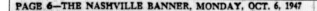

Excavation of Indian Graves Begins At McCabe Field; Relics Are Found

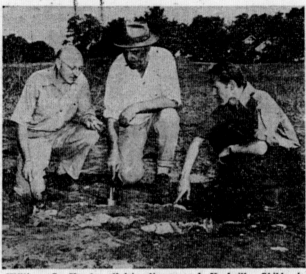

William G. Hassler (left), director of Nashville Children's Museum; Allen Brown (center), engineer in charge of construction of new nine-hole gold course at McCabe Field, and Philbrick Crouch, preparator for Children's Museum, are shown at site of the Indian graves at McCabe Field as excavation work began this morning. They are outlining one of the smaller graves.

Excavation of Indian graves at McCabe Field began this morning under direction of William G. Hassler, director of the Nashville Children's Museum, assisted by Philbrick Crouch, preparator for the museum.

Hassler estimated that the work would take two weeks or more.

Items of pottery or evidences of the life of that period found in the graves will be carefully preserved for the museum. It is planned to have a model made of the grave site which may include one or more of the graves and contents intact as an exhibit for the museum.

There are 12 or 13 outlines of stone-lined graves already uncovered, and indications are that others may be found in the immediate vicinity of the ancient burying ground.

Hassler expressed the opinion that the Indians who lived temporarily in the vicinity of the grave sites came along after the mound-builders, as the graves were not found in a mound. He said very little is known of Indian life of that period in Middle Tennessee, and archaeologists who have visited the site estimate the Indians buried there inhabited the area between 600 and 800 years ago. Items already discovered in the single grave which has been opened were made of shells, evidently from mussels taken from adjoining streams.

Allen Brown, engineer in charge of the construction of the new nine-hole golf course at McCabe Field and who discovered the burial ground while working at the site of the new No. 11 green of the course, said that recently a stone device, evidently used for preparing skins of animals, had been uncovered near the scene of the graveyard. This device appeared to be a type of scraper. Several arrowheads were also discovered nearby.

Whether or not other items will be found in the graves will await further explorations.

In 1949, a Cohn High School class in Sylvan Park was led on an outing to a site discovered where the McCabe Golf Course was being constructed. There are three documented sites within Sylvan Park where Native American artifacts have been found. In addition to the McCabe Golf Course site (near what is now hole 1 of the north course), other reported sites in the Sylvan Park area are between Fifty-second and Fifty-third Avenues and Elkins and Nevada Avenues (site of the old Byrd Douglas spring), and at the Bosley Spring site near Richland Creek toward West End Avenue.

Two

PIONEERS AND PLANTATIONS

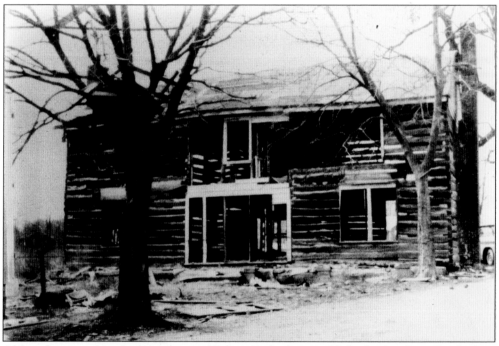

Although not within the boundaries of Sylvan Park, this was likely the first log cabin built in the general area and is typical of structures that would have existed at the time. Located at James Avenue near Twenty-third Avenue, the log cabin is shown here as it was being dismantled in 1970. It is believed to have been where James Robertson and his family stayed from about 1784 to 1787, while they were building their brick home at the location now known as 5904 Robertson Road (that building no longer stands). As plans were being made for the historic restoration of this cabin in 1970, the logs shown in this picture were stored outside. Unfortunately they gradually deteriorated or were taken by others. Some believe several fireplaces in west Nashville boast mantels made from these logs.

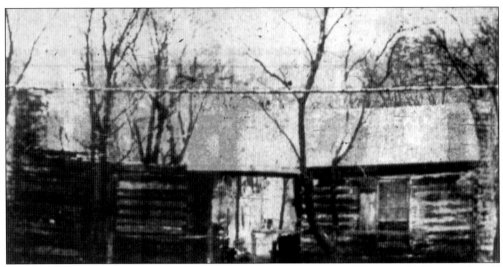

The above photograph survived from a 1954 *Nashville Banner* newspaper article showing the old Dungey Tollgate Cabin, which was then located at 3307 Charlotte Pike. Nearly wiped off the map by an 1830 tornado, Charlotte Pike was rebuilt and maintained through a collective effort. The expense of rebuilding was met by local landowners and tollgate collections—basically a tax on users of the road. The cabin, which was actually two cabins connected by a dogtrot between them, was built in 1843 by Ed Childress and operated as the tollgate headquarters by a freed slave named Will Rawlings and his wife, Mary, until Will's death in 1872. A long pole was lowered across the road and lifted as travelers on wagons and horses paid the fee. Because the fee was requested by a freed slave and his wife, it seems likely touchy situations could have occurred.

As Will Rawlings's health failed, Mary Rawlings's sister, Irene Dungey, moved in with her, bringing her husband, James. The Dungeys ran the tollgate until 1889, when their daughter, Kate Carter, moved in with her husband, Joseph, a former Belle Meade Mansion slave. The cabin was reportedly operated for some period of time at the Richland Creek Bridge before being moved to its final location at 3307 Charlotte Pike. Note the notching on the corners that held the hewn cedar log walls intact for more than 100 years. The deer antlers were from a buck taken near Belle Meade Mansion. With half of the roof gone and the house disintegrating around her, Kate Carter sold the property shortly after the 1954 *Nashville Banner* article. The log home was dismantled and moved to Birmingham, Alabama.

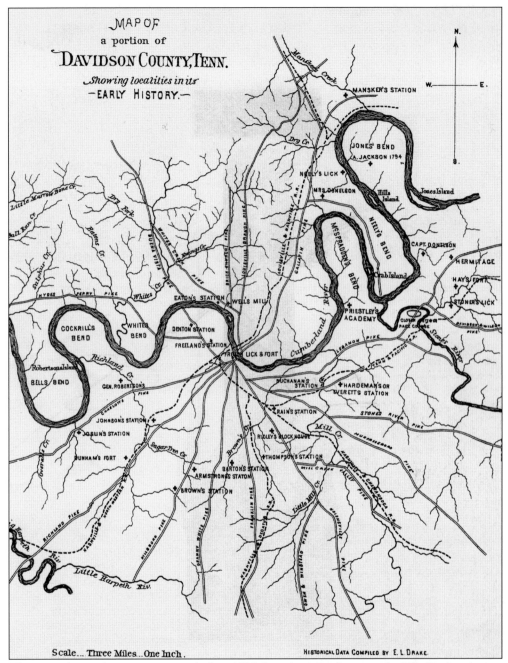

The map above, drawn some time before 1880 from historical surveys by Erle Drake, depicts pioneer times in Nashville.

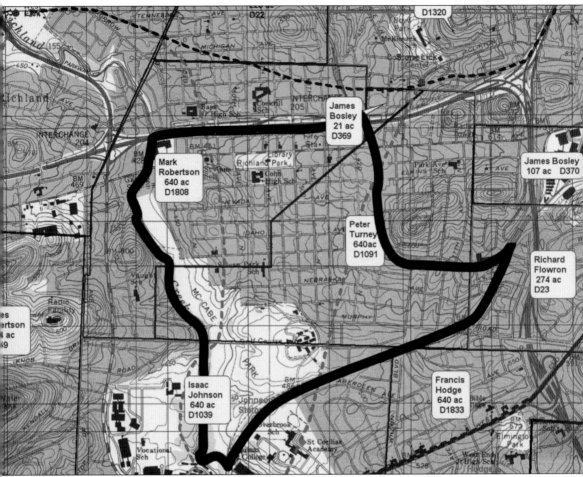

The above map comes from the recent research and survey work published by a trio of Sumner County historians. Sylvan Park resident Beth Kindig added the heavy dark outline showing the Sylvan Park area. It was James Robertson who issued land grants to the first settlers. A large portion of the area to become Sylvan Park was awarded to his brother, Mark Robertson. Mark was killed in a Native American ambush near Richland Creek in March 1786. In a separate incident, James Robertson's 11-year-old son, Peyton, was killed by Native Americans not far from the creek. (Courtesy of Jack Masters.)

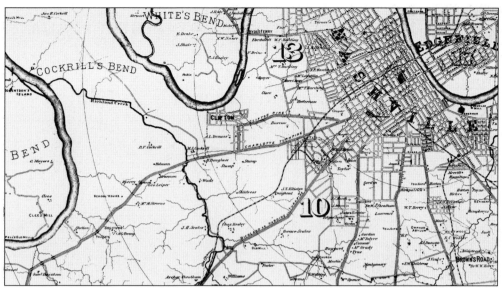

This 1871 map of Davidson County was surveyed and created by Wilbur F. Foster. It provides interesting and authoritative insight into locations of the time.

This close-up of the 1871 map shows the location of the Byrd Douglas, Phillip Stump, and Hewitt Childress plantations in the Sylvan Park area, as the map itself says, "from actual surveys made by the order of the County Court of Davidson County" as "surveyed and mapped by Wilbur F. Foster, Civil and Typographical Engineer." A former senior engineer in the Confederate Army of Tennessee, Foster and his partner, Wilbur Creighton, laid the foundations for Fisk's Jubilee Hall, Vanderbilt's Kirkland Hall, and the replica of the Parthenon at Centennial Park.

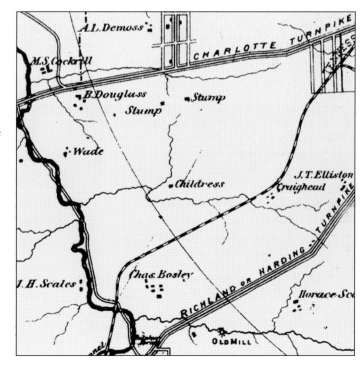

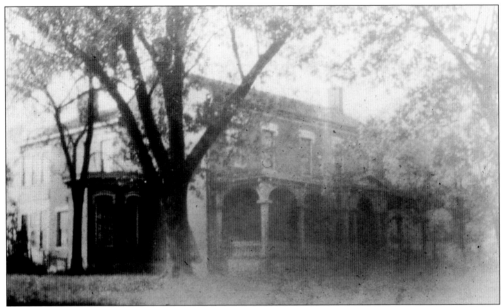

Built in 1848 at the corner of what is now Fifty-first Avenue and Charlotte Pike, the Byrd Douglas mansion was one of the architectural jewels of the area, richly furnished and lavishly detailed. The Victorian front porch and Eastlake spindle work were added after a fire damaged the home. Byrd and his brother, Hugh Douglas, made their fortune as the "Cotton Kings" of Nashville, marketing the material from their Douglas and Douglas warehouse in downtown Nashville.

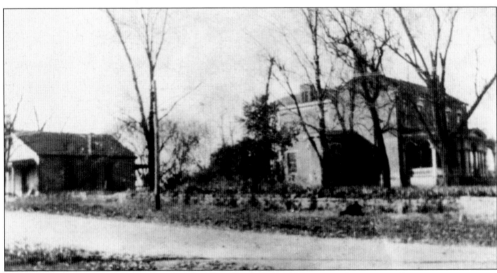

The plain, small house to the rear of the Byrd Douglas mansion was known as the servant quarters or slave quarters. The Byrd Douglas estate farmed wheat, corn, oats, and clover hay, and raised steers, bulls, mules, horses, and dairy cows on more than 218 acres on both sides of Charlotte Pike. Like other Southern sympathizers, Byrd and his brother, Hugh Douglas, suffered during the Civil War. Their immensely successful downtown Douglas and Douglas cotton warehouse was seized for use as a military arsenal by the Union army.

Behind this servant's quarters and down the hill, a clear natural spring provided water for the mansion. Early descriptions mention old stone box Native American graves located near the spring, approximately behind 5204 Elkins Avenue.

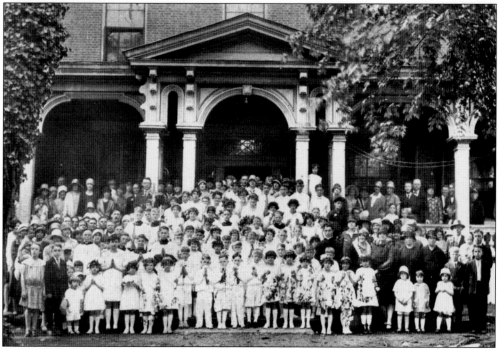

Byrd Douglas died in 1882. Not long after, his daughter, E. D. Richards, sold most of the plantation grounds for land development. In 1900, the mansion was known as the Zarecor Sanitarium, a treatment facility for alcohol, opium, and other drug addictions. Around 1920, it became the property of the Catholic diocese. The above picture shows a May Day celebration held in the old mansion after it had become the site of St. Ann's Catholic Church. (Courtesy of St. Ann's Catholic Church.)

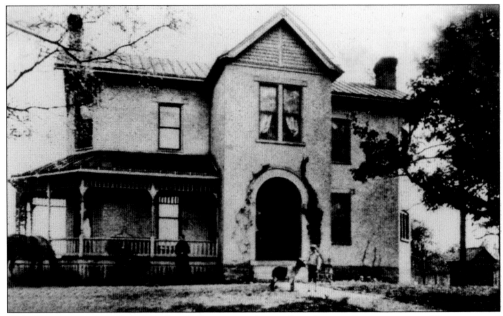

The plantation mansion of Phillip S. Stump was located on the southwest corner of Forty-second and Park Avenues, on a slight rise that is the current site of the Sylvan Glen condominiums. The Stump home was ravaged by Yankees during the Civil War due to Stump's Southern sympathies and refusal to take the oath of allegiance to the Union. Union soldiers split the tall house mirrors with axes.

The Hewitt Childress plantation home was built around 1800 at what is now the corner of Wyoming and Fifty-first Avenues on the Richland Creek side. It faced the creek and the old road to Bosley Springs. The site much later became the location of Metro Social Services' Richland Village.

Three

BUSINESSES

Dr. Henry M. Pierce came to
Nashville from Buffalo, New York,
and was the visionary behind
the Nashville Land Improvement
Company and the 1887 effort to build
a "New Town" or "West Nashville"
(terms used interchangeably to
describe the development). Purchasing
four farms near Charlotte Pike, Pierce
laid out streets, a public park (now
Richland Park), a business district,
and an industrial area along the
Cumberland River. Whether due to
the failure of that industrial area or
his reputedly lavish spending, within
a year, Pierce was financially ruined
and left the area. He financed the
railroad spur that ran from Nashville
to his Cumberland River industrial
area using $100,000 of his personal
funds. After that development
failed, he deeded it to the Nashville,
Chattanooga, and St. Louis Railroad
Company in exchange for a final 5¢
fare ride. His marketing of "Dr. Pierce's
Golden Medical Discovery" helped
him later recover financial health.

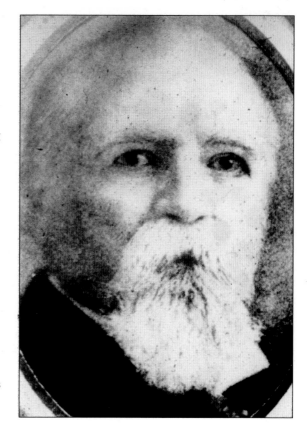

A Confederate captain during the Civil War and a man with an obvious no-nonsense visage, Mark Sterling Cockrill took the reins from financially broken Pierce. It was Cockrill's leadership and the acumen of Lemuel H. Davis that carried the West Nashville Land Improvement Company through hard times, leading some to call Mark Sterling Cockrill the "Founder of West Nashville."

Realtor, bank director, board member, builder, and businessman, Lemuel H. Davis was a primary figure in the growth of West Nashville and an original member of the board of directors of the Nashville Land Improvement Company. He also served as president of Davis, Cockrill, and Finegan real estate, director of Fourth National Bank, and president of the West Nashville Building Company. He was considered a real estate expert and worked with Cockrill both as a business partner and a force to improve education in the area.

Built in 1894 at a cost of $4,783.26, James A. Bowling had Richland Hall constructed with funds from the sale of prison farmland. It is the oldest building in the West Nashville business district and still stands at Forty-ninth Avenue and Charlotte Pike. The walls are 17 inches thick, and the tongue-and-groove floors are inlaid with decorative oak. When the building was used as a general store, deceased Confederate general Stonewall Jackson's name was used to sell merchandise, implying two things: lawsuits concerning the commercial use of personal names were not feared, and Confederate sympathizers likely abounded in the area. But the advertising ploy wasn't completely a marketing technique; there really was a grocer at the store named Stonewall Jackson, of no relation to the famed general. Richland Hall was beautifully restored in 1983. During the 1920s, rooms were rented on the third floor, and the business was known as the Richland Park Hotel.

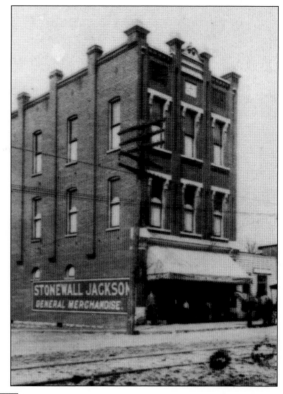

Officer Thomas Murray was a well-known figure along Charlotte Pike at the turn of the century. He was a foot patrolman who guarded the businesses and patrons in the West Nashville shopping district. He is shown here walking his beat at Richland Stables. From 1910 to 1911, Benjamin L. Kennedy Livery Stables was located at 5416 Charlotte Pike next door to James M. Jennett's blacksmith shop. From 1912 to 1915, J. M. Deknoblough Livery stables was located at 5401 and 5403 Charlotte Pike.

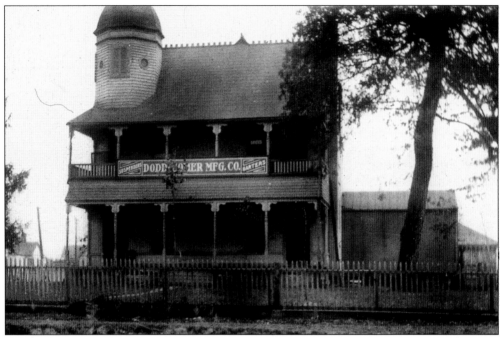

The Exchange Building was constructed in 1887 to be the hub of the new land development that would one day become generally known as Sylvan Park. Located at the Charlotte Pike end of what is now Forty-fifth Avenue, the importance of the building is believed to be the reason that Forty-fifth Avenue remains considerably wider today than other streets and ends before it gets to Charlotte Pike. Called the New Town Courthouse, the Exchange Building also served as the birthplace of Park Avenue Baptist Church and the Dodd Comer suspenders business (note the sign on the building) that became the "DeeCee" (their initials) jeans and overalls business of Washington Manufacturing. It was also the first apartment building in West Nashville. The building was dismantled in 1957. In 1971, the site became the home of the new West Nashville branch of the U.S. Post Office, which still stands on Charlotte Pike.

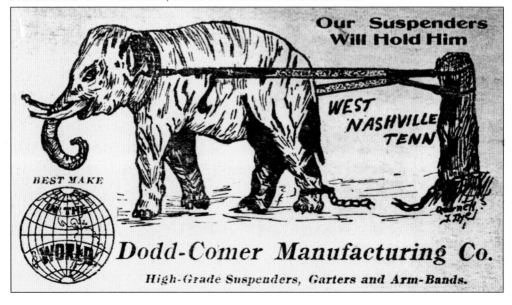

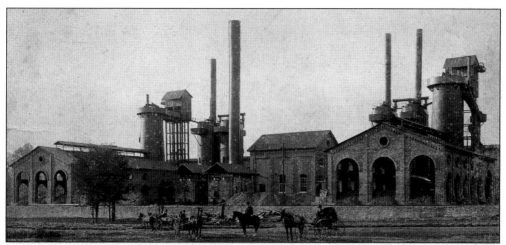

Above is the huge Nashville Iron, Steel, and Charcoal Company factory, one of several bankrolled by Dr. Henry M. Pierce along the Cumberland River to serve as nearby places of supply and employment for his West Nashville land development. This photograph by Thuss, Koellein, and Giers is from 1887. A note on the back of the photograph indicates the corporation ended five years, later in 1892. (Courtesy of the Nashville Public Library, the Nashville Room.)

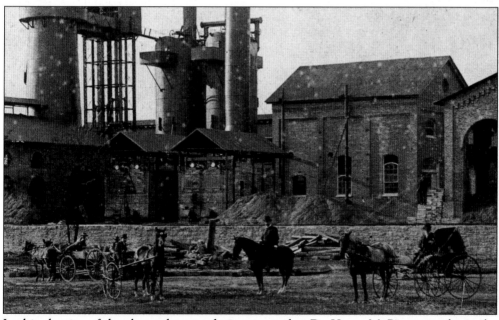

In this close-up of the above photograph, it appears that Dr. Henry M. Pierce may be in the buggy on the right. He started more than a dozen businesses along the Cumberland River near West Nashville that did not survive the Panic of 1893. (Courtesy of Nashville Public Library, the Nashville Room.)

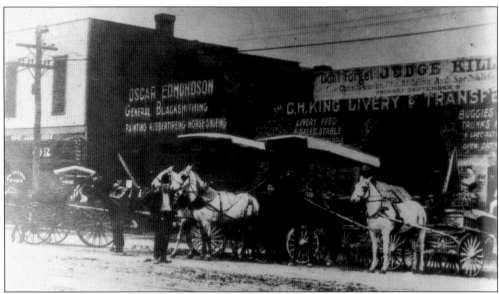

In 1912, Herb King's Livery Stables was located at 4812 Charlotte Pike, possibly sharing the space with Richland stables. Within three years King had moved to 4908 Charlotte Pike next to the village blacksmith, Oscar Edmondson. Edmondson did painting, repaired automobile rubber tires, and shoed horses. Customers often left their horses with Edmondson while attending to their weekly shopping in the area.

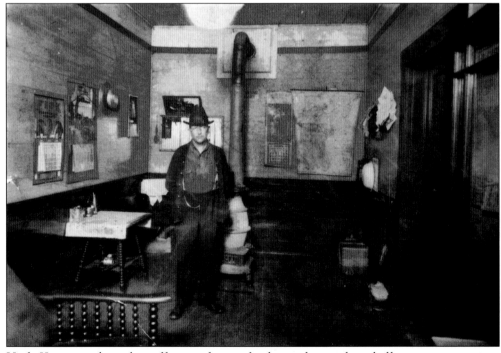

Herb King stands in his office in front of a heat-whitened potbelly stove some time around 1912.

In the early 1900s, fresh milk could be delivered to customers' doors in Sylvan Park by the Westview Dairy. Located on the Orlando Hill bluff overlooking Richland Creek, James B. Watts's products were delivered by his son, Robert, and horse, George. Robert married his Utah Avenue customer Estelle Cullum.

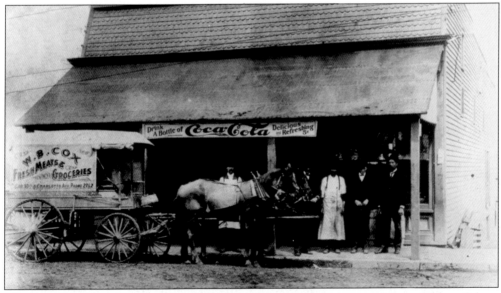

The convenience of groceries delivered by horse-drawn wagon was a service available to Sylvan Park residents as late as World War II, when gasoline was scarce. W. B. Cox's grocery was located at the northwest corner of Fifty-first Avenue and Charlotte Pike, where the gold-domed Regions Bank is now located. Gleaves' Drugstore later occupied this site.

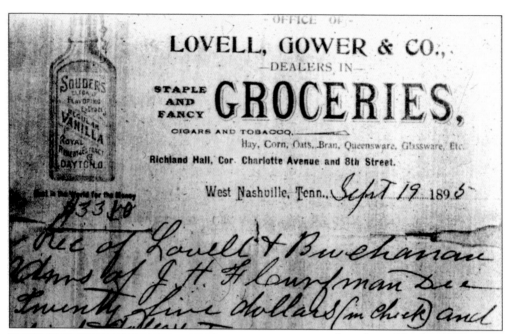

LOVELL, GOWER & CO.,

—DEALERS IN—

STAPLE AND FANCY **GROCERIES**,

CIGARS AND TOBACCO.

Hay, Corn, Oats, Bran, Queensware, Glassware, Etc.

Richland Hall, Cor. Charlotte Avenue and 8th Street.

West Nashville, Tenn., Sept 19 189 5

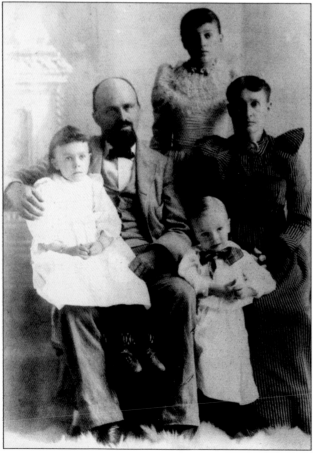

As indicated by this 1895 receipt, Lovell and Gower is believed to have operated the first grocery store in West Nashville. Perhaps they extended credit to some patrons, because $25 would have bought a lot of groceries in 1895.

As co-owner of the local grocery store and president of the Bank of West Nashville, Frank P. Lovell may be counted among the area's early successful businessmen. He and his family, shown at left, lived at Fiftieth and Elkins Avenues.

The Bank of West Nashville, located at 4918 Charlotte Pike, one block down from Richland Hall in 1905, served West Nashville for more than 50 years. Early managers and tellers included Warren Sloan and Wendell Smith.

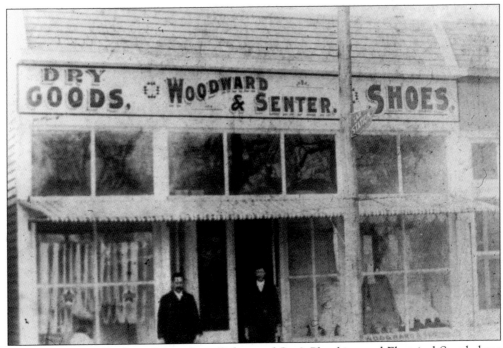

In 1903, at 4908 Charlotte Pike, where Cohen and Son's Plumbing and Electrical Supply later stood for many years, R. L. Woodward and James Senter opened a dry goods store.

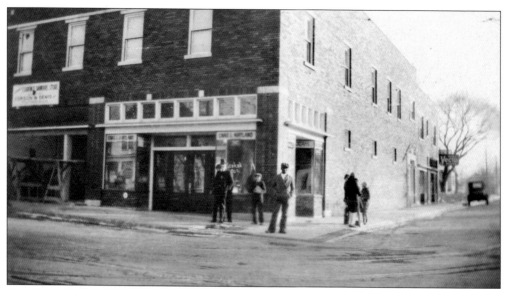

The Sloan Building was built in 1927 by Warren Sloan. It originally housed Kirtland's Drugstore (later Lovell's Drugstore), and the post office and lodge rooms upstairs.

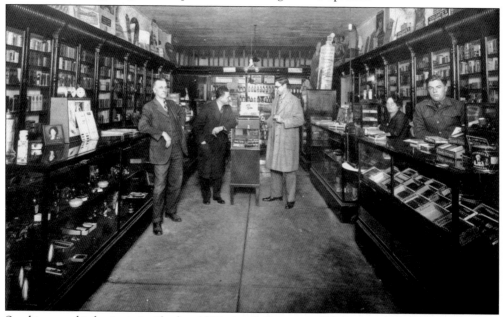

Smoking was big business inside the old Kirtland's Drugstore. This picture is believed to be from the mid-1930s. Other businesses sharing Sloan Hall in 1944 were Bibb Dry Cleaning, Dorris Drugs, Dr. Reynolds, Miss Martha's Beauty Hall, Sadler Electric, and H. G. Hill's grocery store. H. D. "Doc" Martin started cutting hair in the Sloan Building on Charlotte Pike in 1929 and continued for 37 years. When he started he charged only a quarter per haircut, but when he retired in 1967, he had inflated his price to six quarters. Still, he thought he could buy more with the one quarter in 1929 than he could with six in 1967. He said he was looking forward to retiring while he still felt fit enough "to go bear huntin' with a buggy whip." He retired with a 28-inch diameter ball of twine he started collecting nearly seven years earlier, one piece of twine from each delivery of fresh barber towels that was delivered to him. He died on April 22, 1970.

Dr. Rufus Allen traveled to treat patients throughout Sylvan Park at the turn of the century in his buggy pulled by his mare, Ethel. Several babies were delivered with Dr. Allen's help in the homes of Sylvan Park. Allen's residence was at 4700 Charlotte Pike, where the Elite Theatre later stood. His uncle, Dr. Purdy Allen, practiced out of his home at what would become the site of the Sloan Building. Dr. Purdy Allen was unfortunately shot dead by an angry patient.

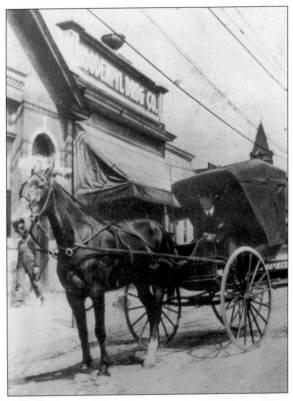

In 1898, Dr. John Beck Hill's home and office was at the southwest corner of the streets now called Fifty-third and Nevada Avenues. Dr. Hill's son later built a residence for himself one block away on land his father owned at Fifty-fourth and Nevada Avenues. Sara Foster Kelley wrote, "My mother, Lavinia Hill Foster, was born in this same house in 1914." Hill also owned 13 acres of land bordering Richland Creek and the present-day McCabe Golf Course.

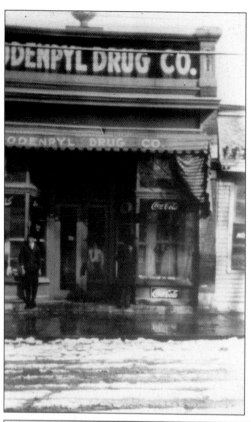

Built in 1905, Hoodenpyl Drug Company's grand opening hosted 2,000 visitors with orchestral accompaniment, free frappe and ice cream, beautiful souvenirs, and gleaming marble and wire chairs. A self-taught pharmacist who achieved the title of doctor, Hoodenpyl became famous for his "Quick Relief Cold Tablets." In 1942, the site was the location for Kuhn's five-and-dime store, known as Kuhn's Variety Store. At Easter, the business sold colored baby chicks to children. The building burned down in 1977. Mrs. Winner's Restaurant operated on the site. Now Church's Fried Chicken does.

Dr. Maurice P. Hoodenpyl and his wife, the former Pearl Linehan, operated their drugstore for 20 years before selling it in 1926 and moving to Long Beach, California, to start a new apothecary.

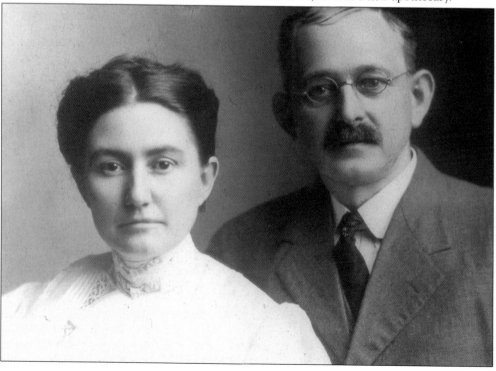

Born in 1836, Dr. Willoughby Dozier was the progenitor of a long line of Dozier physicians. He resided at 4905 Park Avenue, kept an office next to Gleaves' Drugstore on the corner of Charlotte Pike and Fifty-first Avenue, and continued doctoring through his early 80s. His sons, Willoughby Dozier Jr. (pictured here), Bates Dozier, and Robert Lee Dozier, all practiced medicine in Nashville, as did a number of their sons and grandsons. In their long careers, Willoughby Jr. and Bates must have helped birth a fair portion of Nashville's population; the brothers reputedly delivered 7,500 and 10,000 babies, respectively. The population of Nashville in 1900 was just over 80,000 people.

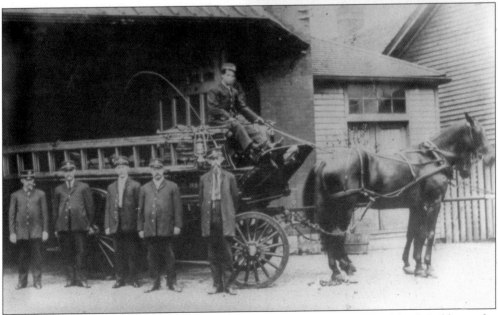

The first volunteer fire department in West Nashville was located in Richland Stables at the 4800 block of Charlotte Pike. To quicken response times, harnesses were suspended where the trained horses would walk quickly into them at the sound of the fire alarm.

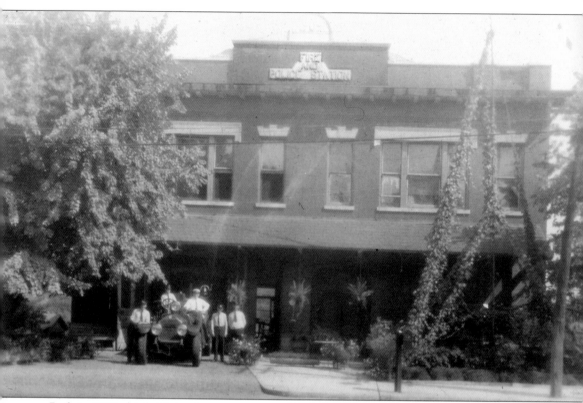

Built in 1909, this brick headquarters was used for both police officers and firefighters. Located at 4406 Charlotte Pike, it was the successor to the volunteer horse-drawn fire department's hall. The west side of the building housed sleeping rooms, a fire pole, and, originally, horse stalls. The east side contained the police quarters and jail. The upstairs was largely for meeting and voting activities. A men's club called the Red Men's Club of America was known to meet there sometimes in jocular celebration of a Native American they called "the Great Incahuni." There was also a women's auxiliary known as the Pocahontas Club. Minstrel shows were sometimes held here as well. A 1917 West Nashville newspaper advertised a straw vote for the mayor of Nashville held here as "a pleasant diversion to the routine of life's daily grind." Awards for those elected were the title of "Mayor of West Nashville" and a "full 24-pound sack of the best flour sold on the West Nashville market" for the first place nominee; the title of "Vice-Mayor of West Nashville" and a "peck of good Irish potatoes" for the second place winner; and title of "City Recorder of West Nashville" and "a choice Belgian hare" for the third-place candidate. Ironically, this building burned down in 1935 while the firemen were fighting a fire elsewhere.

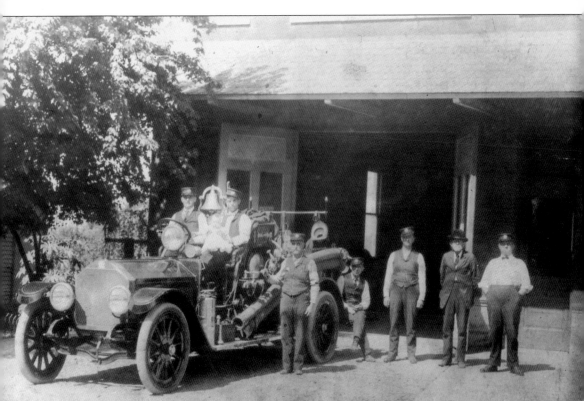

Driven by engineer Joseph C. Reynolds, fire hall No. 13's first motorized fire engine is pictured above around 1916. Reynolds was the grandfather of Steve Johnson, one of the owners of Johnson's Meat Market, formerly located off Fifty-third Avenue near Charlotte Pike. About 30 years after this picture was taken, when iron fire alarm boxes were still on telephone poles, this fire department was plagued by false alarms. After several such incidents, the assistant chief came out to help find the problem. This was before there were streetlights on Charlotte Pike, and it was pitch black at night. One fireman happened to shine his flashlight up a pole that had an alarm box on it as well as a tented work platform above it that the phone company had temporarily put there while its workers were repairing wires. There the fireman illuminated a young boy enjoying the scene he was creating by shimmying down the pole, pulling the alarm and climbing back up into the tented platform.

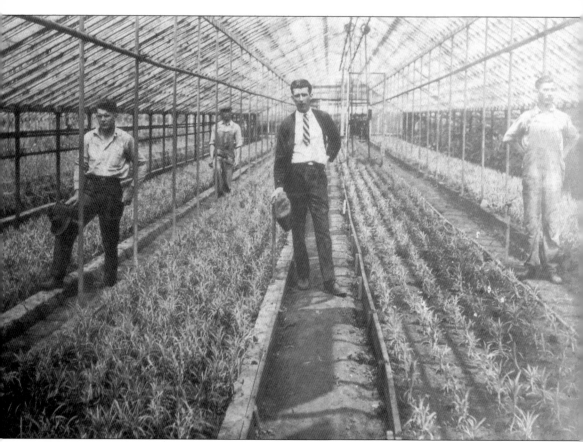

Begun in 1868, Geny's Wholesale Florist is one of the oldest family-owned businesses in Nashville. Leon and John Geny arrived in Nashville in 1858 from Alsace, France, to construct the legendary lavish gardens of Joseph and Adelicia Acklen at Belmont, now Belmont University. John Geny could not find work teaching French, so he started a flower business, originally selling at the farmer's market near the downtown courthouse. By 1906, his business moved to Morrow Road, near James Robertson's home, and by the late 1920s, it had moved again to Sylvan Park at Sloan Road (now Cherokee Avenue) and then to Westlawn Drive. Carnations and "football mums" were raised at the Morrow Road site and potted plants at the Sylvan Park location. The date of the above photograph is unknown, but the appearance is consistent with other photographs of the Sloan Road site in Sylvan Park. The man with the tie is John Thomas Geny, born in 1900. He is the uncle of the latest John Geny to run the family business, who currently operates the store at 4407 Charlotte Pike. The other men in the picture are believed to be Jack Dorris, Gene Sawyers, and Irvin Reynolds.

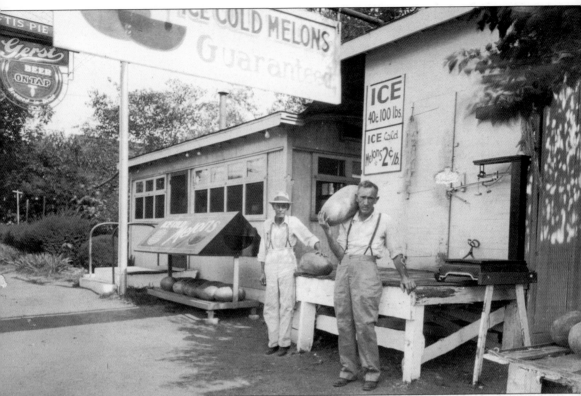

Pictured above holding the melon is Henry Clay Loftis, founder of Loftis Lunch. A longtime railroad carpenter, Henry built the restaurant as if it were a railcar. He later added non-functional wheels so it could pass city building codes as a "pie wagon." His father, Laban Jasper Loftis, purchased the entire Forty-Second Avenue and Charlotte Pike corner in 1887. Laban built his home at 338 Forty-second Avenue. His son, Henry, built Loftis Lunch Room in 1929 at this site, where Loftis Grocery originally stood. Henry's son, Earl "Goofy" Loftis, ran against Percy Priest for public office, with the motto "a chicken in every man's pocket." Descendants of the Loftis family remain in the Sylvan Park neighborhood to this day. (Courtesy of the Bryant family.)

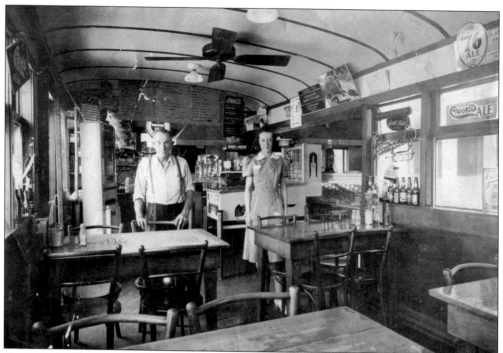

Photographed here are Henry Clay Loftis and his niece, Bertha Lamar, from Kentucky. In 1984, Loftis Lunch had the oldest beer license in Nashville. Early in its history, it stayed open all night. According to an August 15, 1984, article in the *Tennessean* by Susan Armistead, servers like Nina Loftis had to "catch a curb" by running out to take an order when a car stopped and honked. Nina, age 75 in 1984, worked there for 60 years. (Courtesy of the Bryant family.)

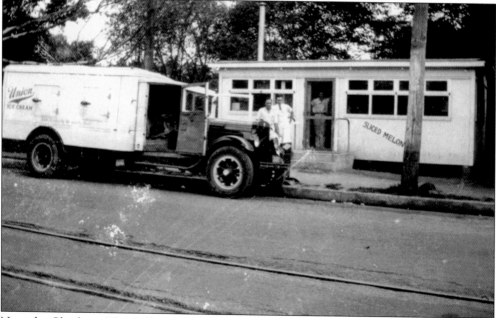

Note the Charlotte Pike trolley tracks in the above photograph. The shiny new 1927 Mack ice cream truck dates this image to about 1929. (Courtesy of the Bryant family.)

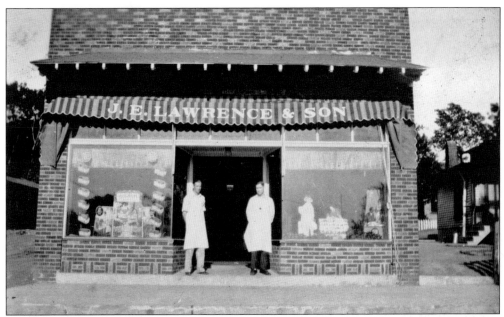

The J. E. Lawrence and Son grocery store operated from 1926 to 1953 at this Forty-fourth Avenue and Elkins Avenue site. Grocery stores like it in Sylvan Park offered delivery to their patrons and let customers purchase on credit.

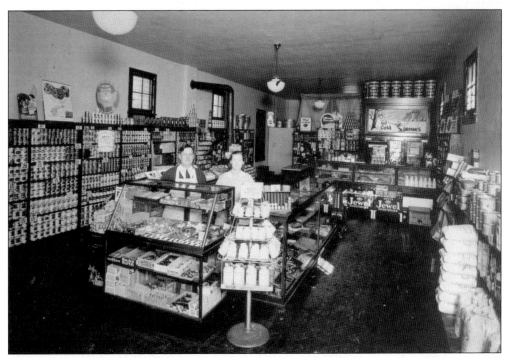

Grocery workers would regularly pick up fresh produce and sell it on the street. J. E. Lawrence and Son Grocery was typical of these small, family-run, one-room stores. Later a coin-operated laundromat operated in the building, which still stands.

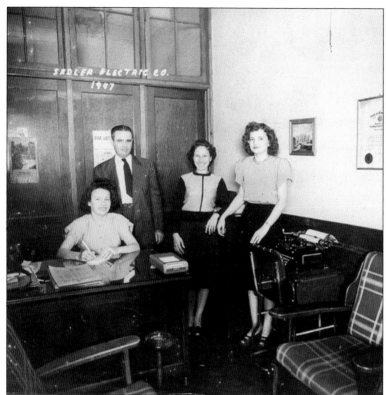

Brothers Joe and William Lee Sadler started the family electric contracting business in 1925. Joe was a city councilman and longtime Sylvan Park resident. The brothers are cousins to Don Sadler, of the current gas station and Sadler Automotive located at Fifty-first Avenue and Charlotte Pike. (Courtesy of Connie Sadler Putman.)

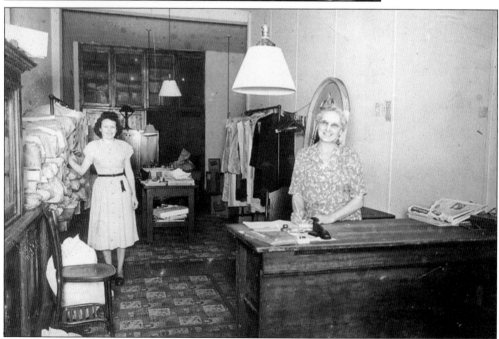

In 1944, the Sloan Building was sold to A. B. Pratt. The businesses in the Sloan Building that year were Dorris Drugs, Mrs. Bibbs's Dry Cleaning (shown above), H. G. Hill, Dr. Reynolds, Miss Martha's Beauty Hall, and Sadler Electric. (Courtesy of Connie Sadler Putman.)

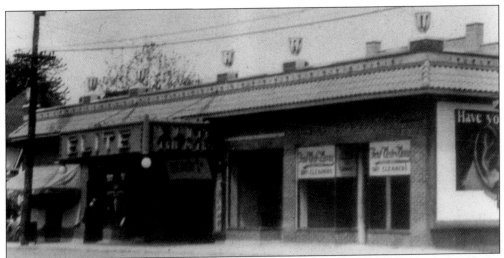

For decades, the Elite Theatre was an entertainment staple of West Nashville. Starting in the 1920s at a series of locations along Charlotte Pike, it took residents to space with Buck Rogers and to the Wild West with Gene Autry. In 1948, Tuesday matinees were sponsored by a local bank; during the matinees, moviegoers could register their names to be pulled out of a wire barrel to win as much as $200. A Sylvan Park resident who was five years old in 1931 remembers going to movies at the Elite Theatre with his older brother. The boys took a shortcut through a wooded area at Forty-second and Wyoming Avenues to get to the theater, and it could seem scary at night. On the way from a Boris Karloff movie, the older brother would say, "Watch out, he's coming up behind you!" "Even though I was only five, they couldn't outrun me," the resident recalls of his older companions.

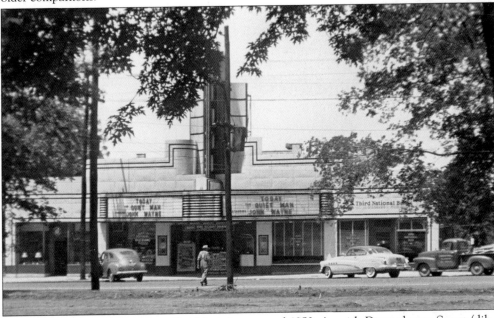

Above is the Elite Theatre at its final location around 1950. As with Demonbreun Street (dih-MUNH-bree-uhn), true West Nashvillians can be identified by how they say certain words. Spoken by a West Nashvillian, the first name of the Elite Theatre is pronounced "EE-light." (Courtesy of Donald Harris.)

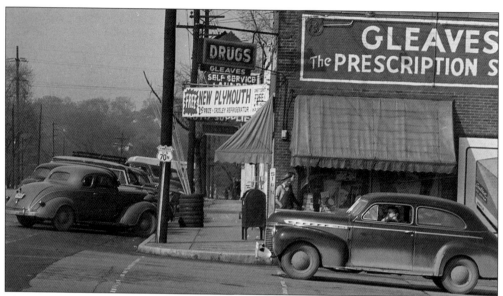

The cars in this photograph date the time period to the early 1940s. This picture was taken while the photographer was standing in front of the 5024 Charlotte Pike site of a 1937 Krispy Kreme Doughnuts Shop, the first in the country. George Zepp noted in a July 18, 2009, *Tennesseean* article that its place in history had been "glazed over." Also in the late 1930s, just beyond Gleaves' Drugstore, a colorful whiskey bootlegger operated his shop. He had a gruff voice and a steel hook instead of a right hand. One resident recalls how he used to reach out for youngsters with his hook and say, "C'mere boy!" About once a week he reportedly held boxing matches in the back of his shop, but it was blocked off, and anyone he did not know was not allowed in. (Courtesy of Metro Archives.)

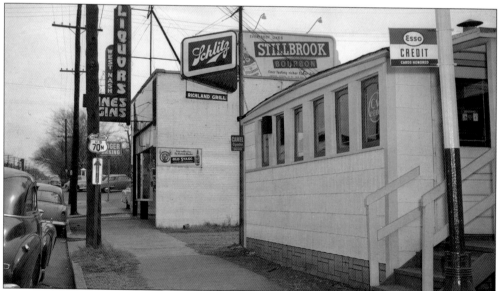

This view from around 1952 is toward Nashville on Charlotte Pike, with Richland Park just beyond the pictured liquor store on the right. The closer building on the right below the Schlitz sign is another "pie wagon"—the Richland Grill. Opened in 1931, it was also known as Elmore Woods Restaurant and, much later, as Meredith Derryberry's Diner. (Courtesy of Metro Archives.)

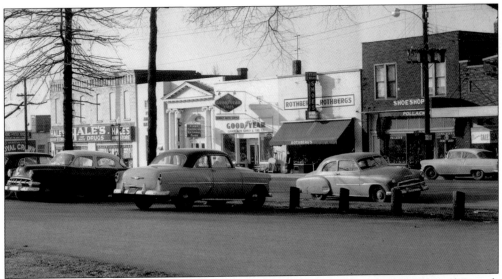

The above view, taken in the late 1950s, is from the location of the current Richland Branch of the Nashville Library, looking across Charlotte Pike. Weise Hall is on the right. (Courtesy of Metro Archives.)

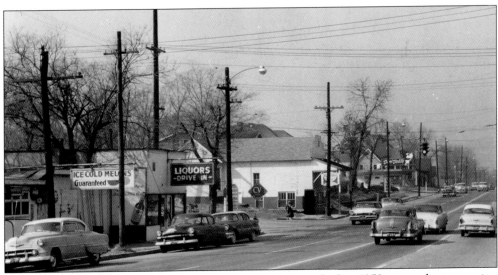

This view looking west on Charlotte Pike is most likely from the late 1950s, since the car coming down the left lane toward the viewer is a new-looking 1957 Ford Fairlane. Note Loftis Lunch next to the drive-in liquor store on the corner of Forty-second Avenue and Charlotte Pike. (Courtesy of Metro Archives.)

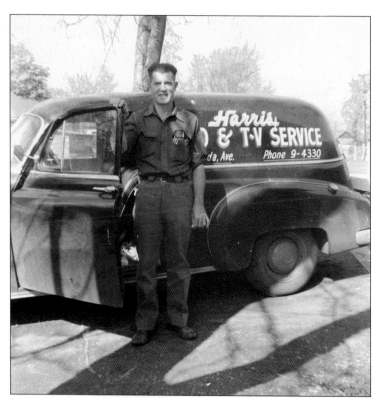

In 1947, Leonard Harris operated a radio and television repair service out of his home at 4410 Nevada Avenue. He had one of the first televisions in West Nashville and often shared it in the evenings by putting it on the front porch so neighborhood kids could watch shows like *Milton Berle* and *Texas Wrestling*. He also owned a Lions gas station at about Thirty-ninth Avenue and Charlotte Pike. (Courtesy of Donald Harris.)

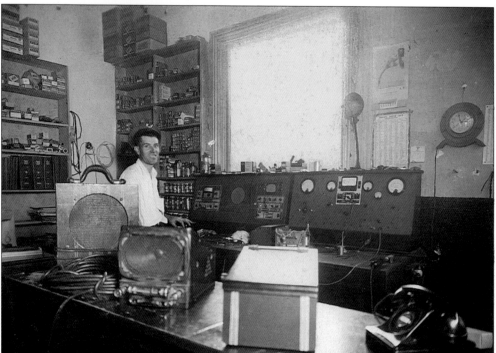

This is an earlier photograph of Leonard Harris inside his Nevada Avenue repair shop. The concrete block building is still standing and is now a rental property. (Courtesy of Donald Harris.)

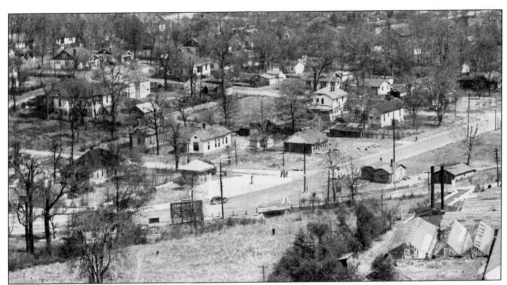

Above is an aerial shot of Murphy Road believed to have been taken about 1933. Note the greenhouses for Geny's Flowers on the right. (Courtesy of John Dean.)

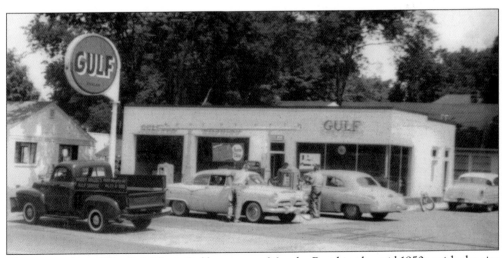

This image shows Woody Miller's Gulf station on Murphy Road in the mid-1950s, with the site of the Sylvan Park Restaurant just to the left of it. Miller's service station operated for 27 years. (Courtesy of John Dean.)

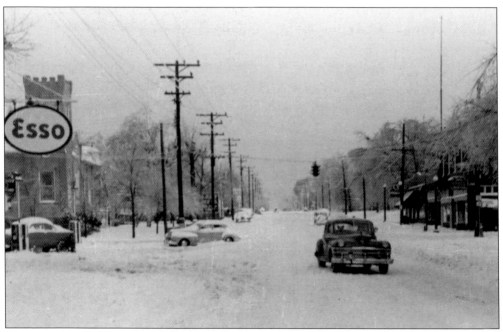

Above is a view looking east on Charlotte Pike, just in front of the Forty-sixth Avenue intersection, during the 1951 blizzard. (Courtesy of Mary Lane Stain.)

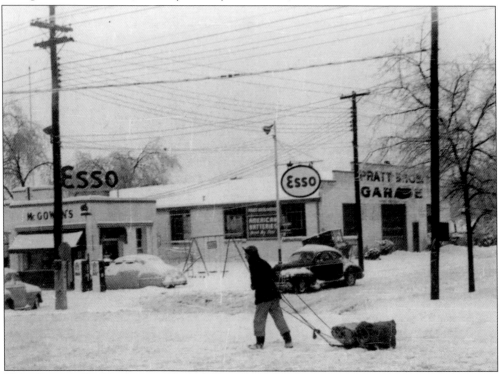

This photograph of someone pulling a loaded sled west on Charlotte Pike at Forty-sixth Avenue is also from the 1951 "Nashville Blizzard." The Charlotte Avenue Church of Christ is out of view, though it is located across the street to the right. (Courtesy of Mary Lane Stain.)

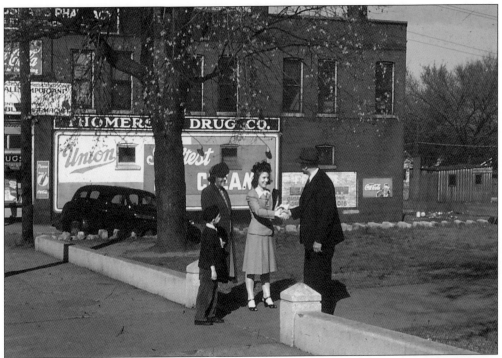

This view of Thomerson Drug Company in the background shows folks leaving West Nashville United Methodist Church, though the church itself is out of view to the right. (Courtesy of Ed Crump.)

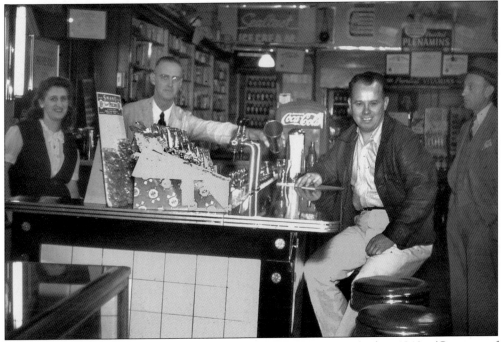

This photograph was taken inside Thomerson Drug Company in the late 1940s. (Courtesy of Ed Crump.)

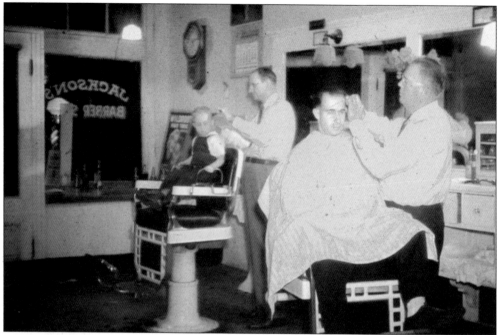

These patrons to Jackson's Barber Shop are probably a father and son. Jackson's opened in 1928 at 4804 Charlotte Pike. (Courtesy of Metro Archives.)

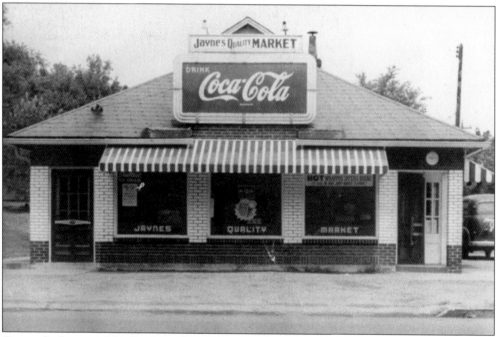

Currently the site of the Produce Place, Jayne's Quality Market on Murphy Road is shown here around 1940. Other grocery stores in the area in 1935 included H. G. Hill at 3639 Murphy Road, Clarence Garrard at 4000 Murphy Road, Cox and Cox at 134 Forty-sixth Avenue, George Earnhart at 4310 Dakota Avenue, and Joseph Lawrence at Forty-fourth and Elkins Avenues. (Courtesy of the Produce Place.)

Four

HOMES

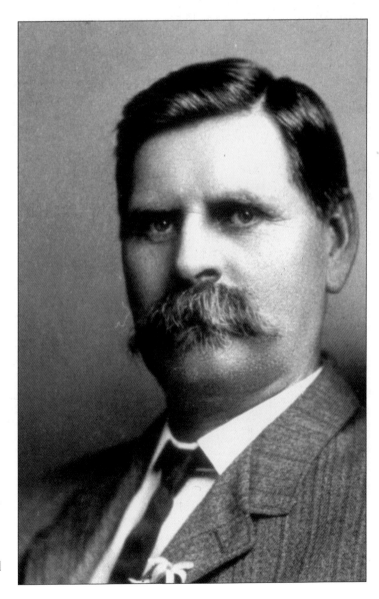

James K. Bowling is
the man whose work
crews built the majority
of the turn-of-the-
century homes in the
area. His own home at
4501 Nebraska Avenue
bore the name that was
later assumed by the
entire neighborhood:
Sylvan Park. He was
vice president of the
Sylvan Park Company
in 1903 and president of
the Sylvan Park Land
Company in 1906. He
built houses to last,
using solid materials and
quality workmanship.

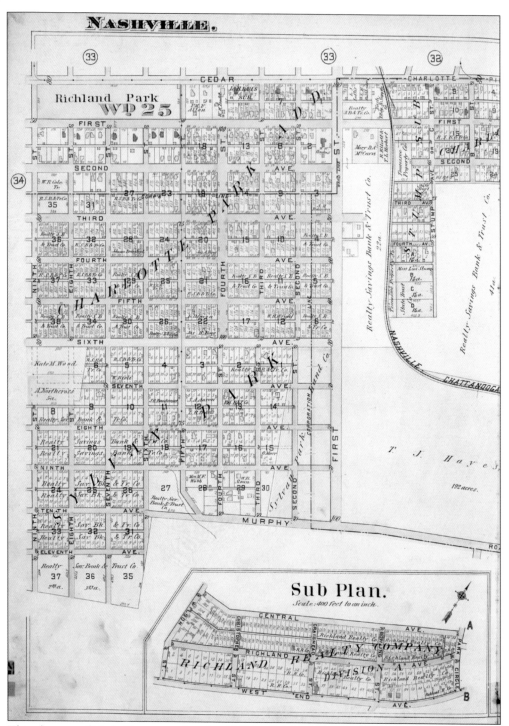

This plat map of Nashville was produced in 1908 by G. M. Hopkins of Philadelphia, Pennsylvania. It shows how Sixth Street, now Wyoming Avenue, was the boundary between the Sylvan Park development of James Bowling and the older Charlotte Park development at the time. (Courtesy of the Nashville Public Library, the Nashville Room.)

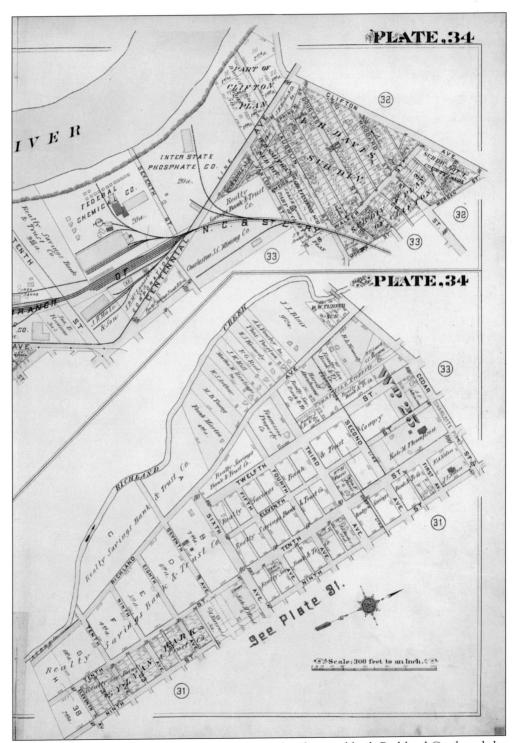

This section of the 1908 Hopkins plat map shows detail around both Richland Creek and the industrial development area near the Cumberland River. (Courtesy of the Nashville Public Library, the Nashville Room.)

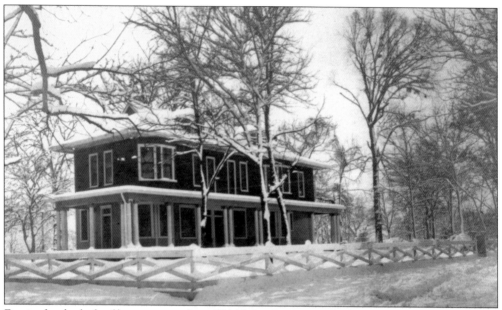

Except for the lack of houses around it, 4501 Nebraska Avenue looks much the same today as it did during one of its first winters. Built in 1904, it was the Bowling residence for many years.

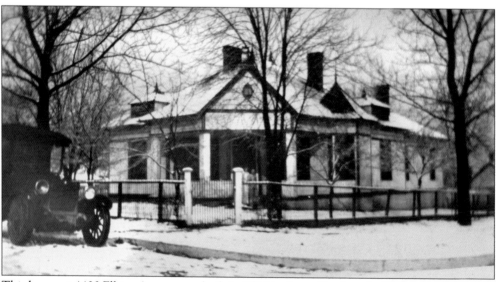

This house at 4400 Elkins Avenue was built in 1904 by James Bowling for William B. Felts, who served as secretary and treasurer of the Realty Savings Bank and Trust.

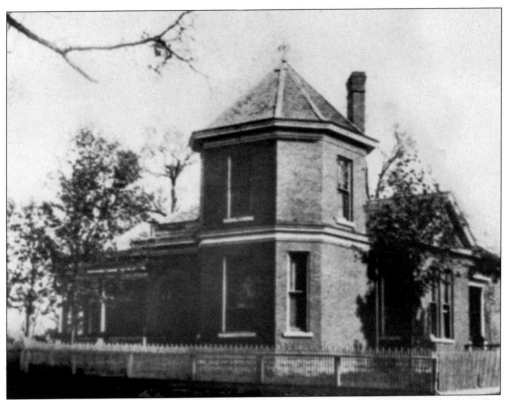

Above is the distinctive Victorian brick hexagonal tower of the F. C. Gutherie home, built at 4711 Park Avenue in 1894. A time capsule was buried on the lot at the end of the initial three-day sale of lots that began on May 24, 1887, and it is reportedly still buried in the front yard. Gutherie was the manager of National Casket Company.

Handwritten receipts were proof homeowners kept to show they had paid their mortgage. The above receipt from the estate of the Loftis family shows how much payments were in the area in 1887. (Courtesy of the Bryant family.)

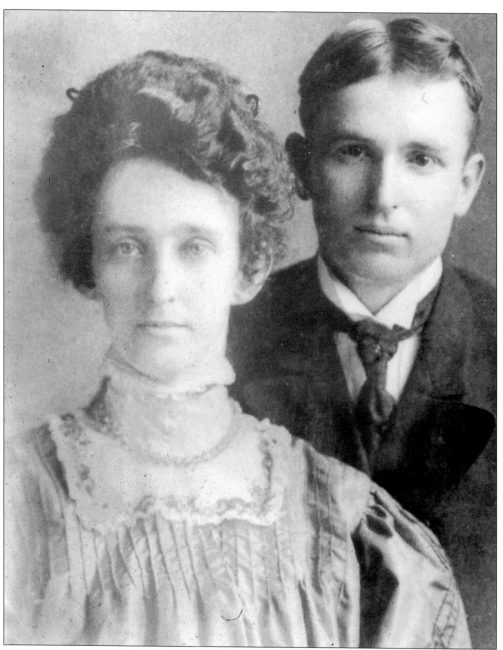

Robinson I. and Aubrey Halls Wrather moved to West Nashville in 1905 and in 1917 purchased the picturesque Queen Anne Victorian house built by Millard Green at 4801 Park Avenue. Wrather was a post office employee and part owner of the Reynolds-Nicks Farm Store on Charlotte Pike. He also founded the Belle Meade Hardware Company on Harding Road.

Shown at right, this Queen Anne–style home was considered by some to be the finest example of Victorian architecture in Sylvan Park. It was built in 1889, one of the first homes in the New Town development, by lumber businessman Millard Green, who used his inventory and connections at his store on 306 Church Street to construct a colorful and ornate home. (Courtesy of the Disciples of Christ Historical Society.)

Now located at 4700 Elkins Avenue, the Millard Green home was moved on rollers from Park Avenue in 1936 in order to allow room for the expansion of Cohn High School.

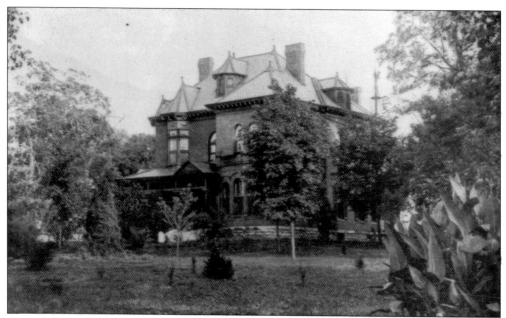

One of the earliest and richest of residences built in west Nashville was the three-story brick mansion of Bishop R. K. Hargrove. Located on a large plot of land at 5001 Charlotte Pike, it bordered the west end of Richland Park.

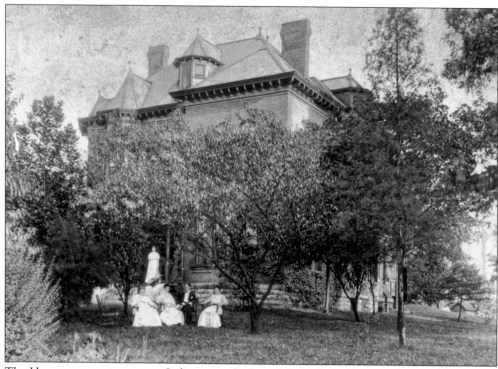

The Hargrove mansion was an Italianate-style showplace befitting Bishop Hargrove's station as the president of the Vanderbilt University Board of Trust and boasted servant quarters, a carriage house, and stables, as well as an impressive domed conservatory on its top floor.

As shown above, the Hargrove mansion towered over other homes in the area. It later became the residence of Judge John L. Nolen and family, then the home of Emanuel Weise—who, in 1901, built Weise's Hall across from the home—and finally a boardinghouse where several employees of Victor Chemical Company rented rooms. The wire fence on the right of the photograph was erected around Richland Park to keep wandering cows from spoiling the area.

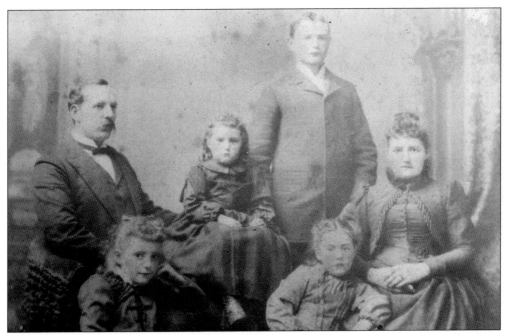

Judge John L. Nolen and family made the former Hargrove mansion their home in the early 1900s. Nolen's grandfather founded Nolensville, Tennessee.

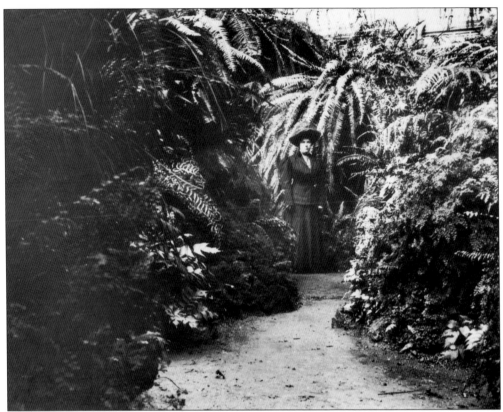

Above is Susan Blackman Nolen standing in the impressive conservatory of the Hargrove mansion, built on the top floor so that natural sunlight could maintain the many ferns and other plants kept there.

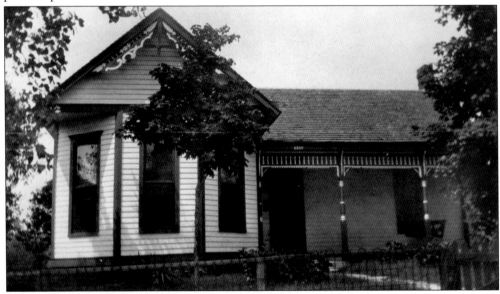

This home at 4500 Elkins Avenue was built in 1901, using materials taken from the disassembly of the 1897 Centennial Exposition at Centennial Park.

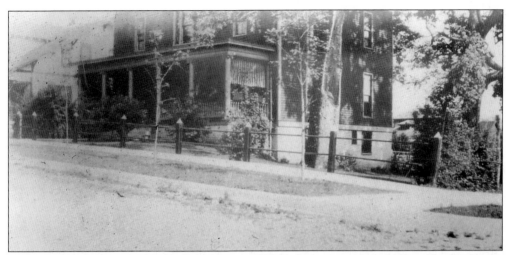

Built in 1903 for Lyman Gates, this home at 4911 Park Avenue was purchased by Dr. Joe D. Goodwin in 1916. For more than 30 years, Goodwin lived in and worked from this home, reportedly delivering the majority of babies in the West Nashville community.

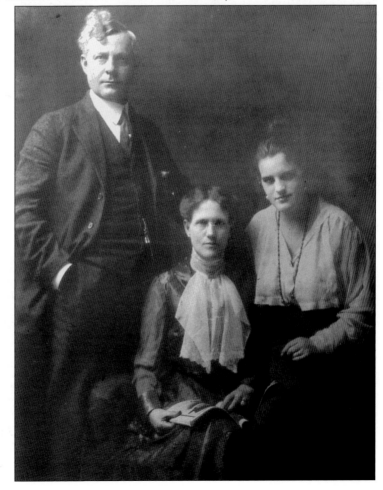

Posing with his wife, Bessie, and daughter, Sarah, Dr. Joe D. Goodwin was one of the early and longtime residents of new West Nashville. He was described as active in civic affairs and an investor in local businesses and community efforts.

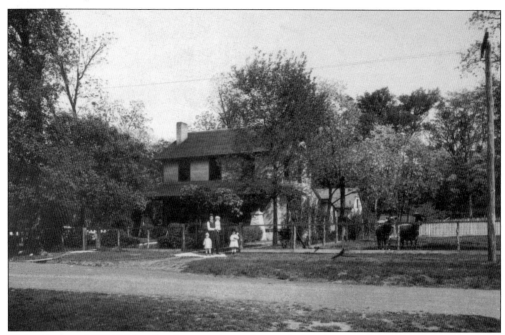

This picture of 4106 Nebraska Avenue shows James A. Bowling with his granddaughters, the Gann girls. The house burned in 1962. Bowling sold his Sylvan Park residence but later returned to the neighborhood in order to be close to his family.

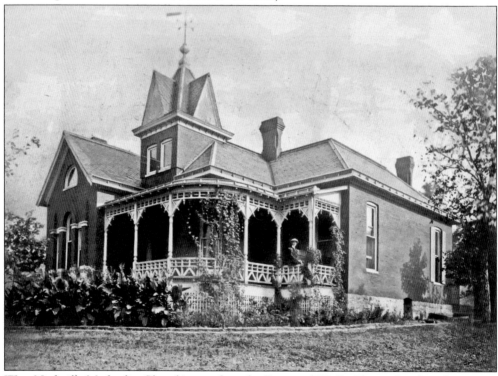

West Nashville Methodist Church's preacher, the Reverend W. D. Cherry, lived in this ornate house at 4207 Charlotte Pike.

Built in 1902 at 4609 Park Avenue, this Victorian brick home with Tuscan columns was first the home of Frederick Schaeffer, general foreman of the Nashville, Chattanooga, and St. Louis Railroad shops. Built to last, its 18-inch-thick walls are set on a limestone foundation. A large galvanized tank in the attic was once a rainwater cistern that supplied water throughout the house.

The first owner of this house, located at 119 Forty-sixth Avenue, was Andrew J. Wrather, the motorman on the Sylvan Park "Dinky" streetcar, which is pictured in the "Transportation" chapter of this book. This residence was constructed in 1905.

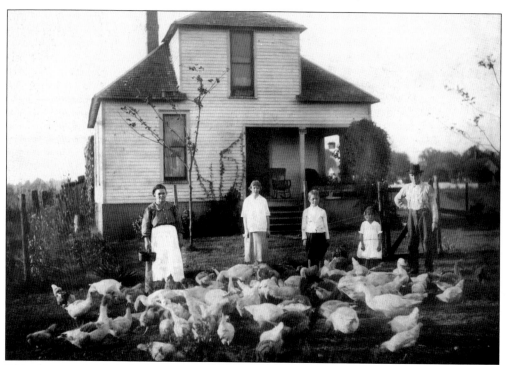

This photograph labels the house as located at 4707 Dakota Avenue. In 1915, it was the home of John Randolph French. One older resident of Sylvan Park remembers nearly every home keeping a chicken or two even as late as the early 1940s.

Sitting in the sun on their front porch at 3809 Murphy Road are, from left to right, Virginia, William Cleveland, and Van Grizzard. Pictured in 1926, this view is from Murphy Road toward West End. There were so few trees and buildings at the time that the old Craighead house (which is still standing today) can be seen clearly to the left of the home. (Courtesy of Jackson and Marjorie Grizzard.)

This two-story Victorian Transitional brick home with Italian Renaissance features at 4601 Park Avenue was built for Benjamin Thomas Young in 1903. A concrete contractor, Young designed the home's concrete porch, window sashes, and flower boxes.

Built in 1900 by Allen Hardison, co-owner of the Hardison-Gillette Grainery, this brick Victorian Transitional home at 4901 Park Avenue later became the home of Hardison's business partner, Frank Gillette. In 1930, the Bean sisters—longtime area schoolteachers—began their nearly 60-year residence in the home.

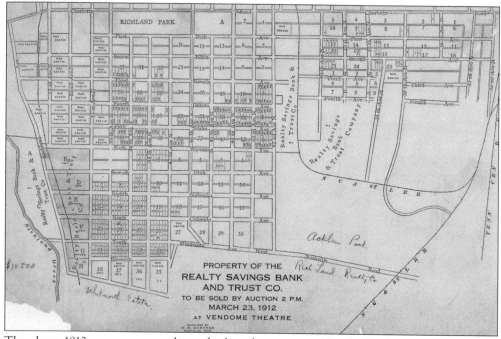

The above 1912 map appears to list only those homes owned by the Realty Savings Bank and Trust Company. Notice that Murphy Road was once known as Minnesota Avenue.

A seminal figure in the development of west Nashville, Lemuel H. Davis built this large two-story brick Victorian home with Greek Revival features at 4703 Park Avenue for his family around 1900. Built on a solid stone foundation and featuring floral-patterned stained glass, ornamental cast brick, half-circle windowpanes, solid pocket doors, brass, etched-glass gas lights, oak floors, quartersawn oak woodwork, and hand-carved fireplace mantels, the Davis house is one of builder James A. Bowling's finest Sylvan Park homes.

Five

CHURCHES

This 1932 cradle roll certificate is from one of the oldest churches in Sylvan Park, Park Avenue Baptist. Like the First Methodist-Episcopal Church (now known as the West Nashville Methodist Church), its congregation met initially in the Exchange Building before receiving three lots from the Nashville Land Improvement Company for the price of $1. Park Avenue Baptist Church's first location was at the corner of Forty-seventh and Georgia Avenues. (Courtesy of the Bryant family.)

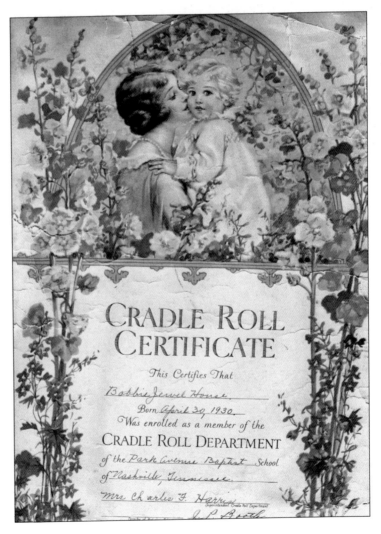

CRADLE ROLL
CERTIFICATE

This Certifies That

Bobbie Jewel House

Born April 30, 1930

Was enrolled as a member of the

CRADLE ROLL DEPARTMENT

of the Park Avenue *Baptist* School

of Nashville, Tennessee.

Mrs Charles F. Harris

J. P. Booth

Named after pastor Robert Boyte C. Howell, Howell Memorial Baptist Church was the second church founded in the Nashville Land Improvement Company's "New Town" area, getting its start in August 1888. After 20 years in the above building on 4604 Georgia Avenue, the congregation moved to the new hexagon-shaped brick chapel on the corner of Forty-fourth and Park Avenues. (Courtesy of Park Avenue Baptist Church.)

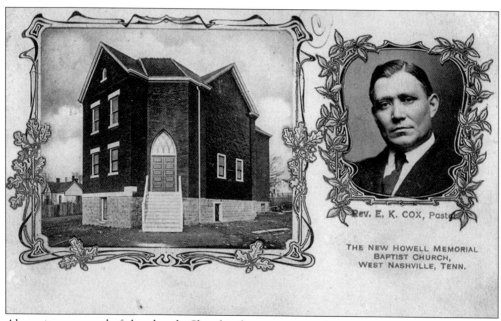

Above is a postcard of the church. Shortly after moving to their new Park Avenue home, the congregation renamed their church from New Howell Memorial Baptist Church to Park Avenue Baptist Church. (Courtesy of Park Avenue Baptist Church.)

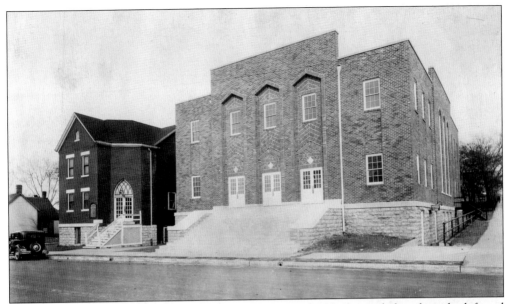

The above picture from around the 1930s shows the original hexagonal chapel on the left and the new building on the right. (Courtesy of Park Avenue Baptist Church.)

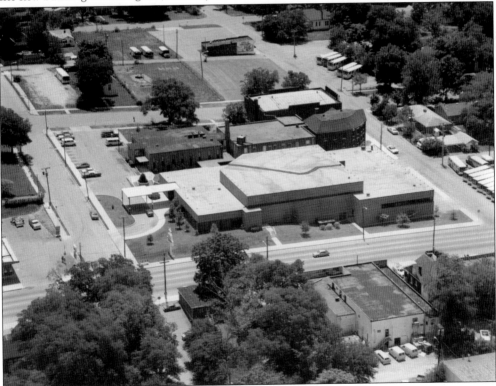

By the mid-1980s, Park Avenue Baptist Church was a complex of buildings that operated dozens of old Nashville city buses to ferry churchgoers. There are 22 buses in the above picture. The Reverend Bob Mowrey presided over this growth period and was pastor of the church for more than 35 years. (Courtesy of Park Avenue Baptist Church.)

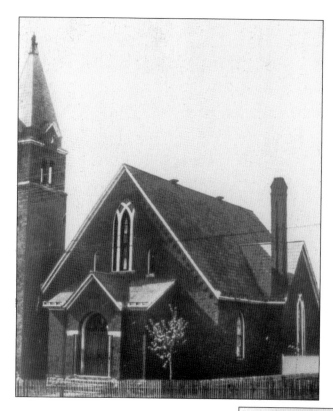

The first church founded in New Town was the First Methodist-Episcopal Church. On July 16, 1888, the Nashville Land Improvement Company signed over three lots at 4700 Charlotte Pike to the church's newly-formed board of trustees for the cost of $1. The bell tower shown here was torn down in the 1950s during other remodeling.

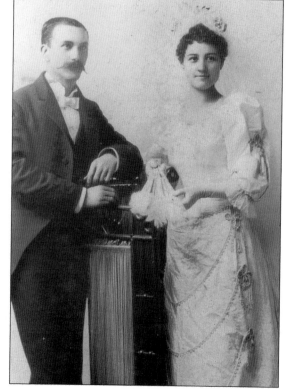

On December 6, 1893, Lorenzo Dow Gower married Davie Ann Byers in the first wedding performed in the new church. Lorenzo went on to become a partner in the area's first grocery store, Lovell, Gower, and Company, which served the Sylvan Park area for 35 years.

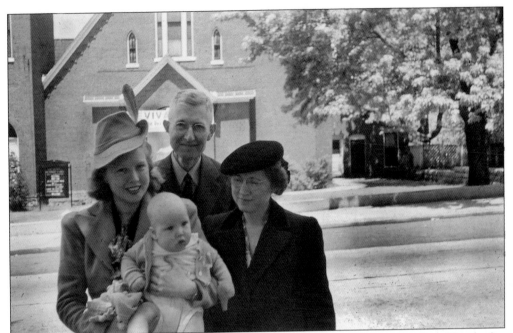

This shows the J. B. Robinson family exiting church services at West Nashville United Methodist Church in the late 1940s. The Robinsons lived at 4510 Colorado Avenue for 60 years. Katherine Robinson was a first-grade teacher at Cockrill Elementary School, and J. B. worked at the Bank of West Nashville. (Courtesy of Ed Crump.)

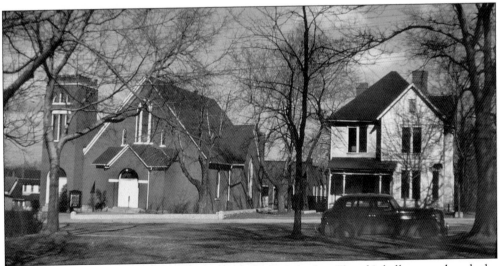

This photograph shows the West Nashville United Methodist Church's bell tower, though the steeple has been removed. The tall chimney on the right side of the church is also no longer there. This picture is from the late 1940s. (Courtesy of Ed Crump.)

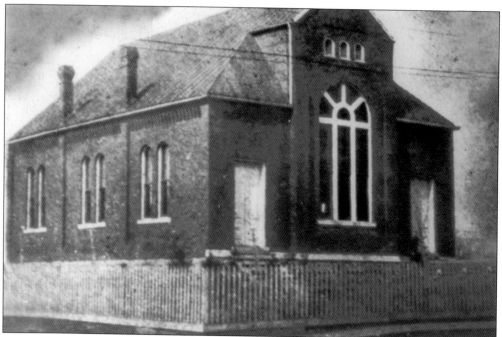

The third church to receive three lots in New Town for the cost of $1, the Charlotte Avenue Church of Christ was officially organized in 1889. This redbrick building was constructed in 1892. The church traces its roots to 1876, when David Lipscomb held a meeting in the area, inspiring the group that began the congregation.

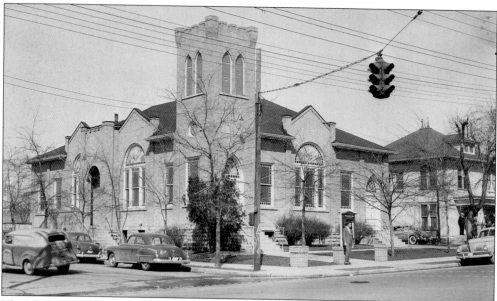

The blonde brick structure of the Charlotte Avenue Church of Christ was built around the original redbrick chapel in 1921. The above picture is from about 1952. As this book was being researched, the church was being demolished, the congregation having already moved into a new church building. The house to the immediate right was initially used as a Bible school by the church pastor, Rev. J. W. Grant. (Courtesy of Metro Archives.)

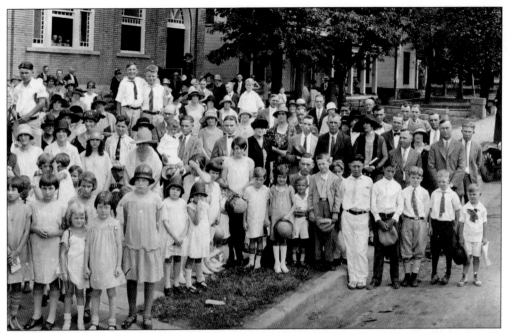

Here is a group picture of the Charlotte Avenue Church of Christ congregation spilling onto the church's front steps with Charlotte Pike to the right. This type of large landscape photograph of the congregation was taken numerous times over the years. (Courtesy of West Nashville Founders' Museum Association.)

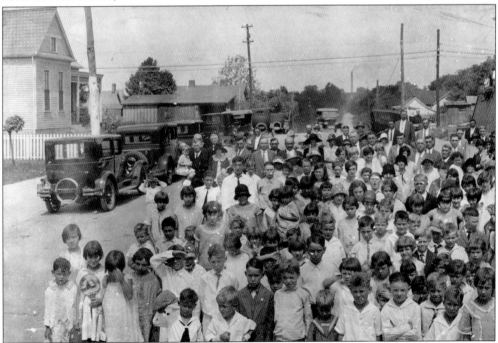

Note the homes on Forty-sixth Avenue to the left, where Pratt's Garage was later built. In current times, the freeway would be visible on the horizon. This photograph was taken around 1926. (Courtesy of West Nashville Founders' Museum Association.)

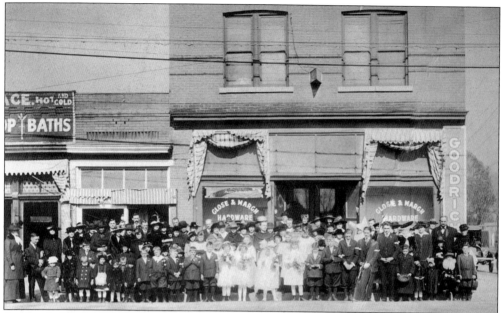

St. Ann's Catholic Church and School began as St. Peter's Mission, a group of worshippers meeting on the second floor of Weise Hall, above the Close and March Hardware Store. The church operated under the guidance of Fr. Peter Pfeiffer, Sr. Mary Thomas, and Sr. Mary Austin. The above photograph is believed to have been taken on Sunday, November 1, 1917, after the First Holy Communion. (Courtesy of St. Ann's Catholic Church.)

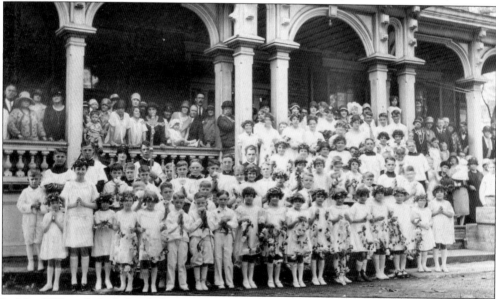

In May 1921, with the help of a bequest by Father Japes of the Church of the Assumption, the old Byrd Douglas mansion at the corner of Fifty-first Avenue and Charlotte Pike (see the "Pioneers and Plantations" chapter), then known as the Thomasson mansion, was purchased from Judy Nolan and remodeled. The second floor was divided into schoolrooms. The wall on the left main floor between the front and back of the house was removed and prepared as a chapel. (Courtesy of St. Ann's Catholic Church.)

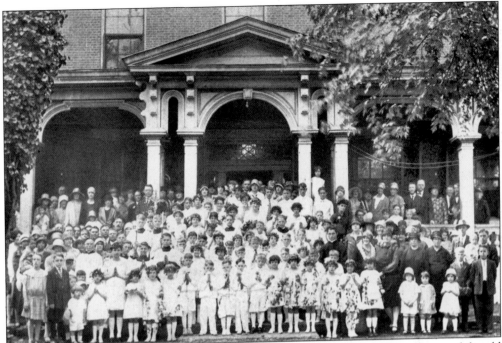

Here the congregation of St. Ann's Catholic Church gathers on the porch and steps of the old Byrd Douglas mansion for a 1930 May Day celebration. This is also a close-up and clear photograph of the old plantation mansion facade. (Courtesy of St. Ann's Catholic Church.)

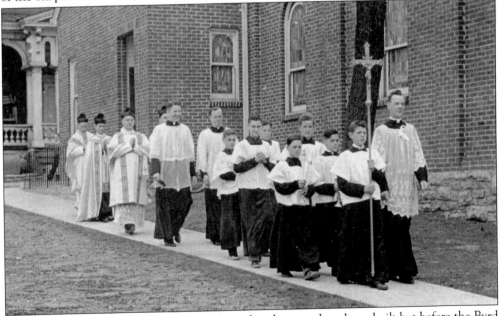

This photograph appears to have been taken after the new chapel was built but before the Byrd Douglas mansion was torn down, since it is still pictured in the back left. Father Quest is leading a procession of altar boys including brothers Jim and Bernard Forte, the latter of whom is carrying the cross. From the rear of the procession forward are Fathers O'Donnel, Leppert, Richardson, and Flanigan. (Courtesy of St. Ann's Catholic Church.)

Pictured is St. Ann's new brick chapel when it was built in 1939, facing toward Charlotte Pike. (Courtesy of St. Ann's Catholic Church.)

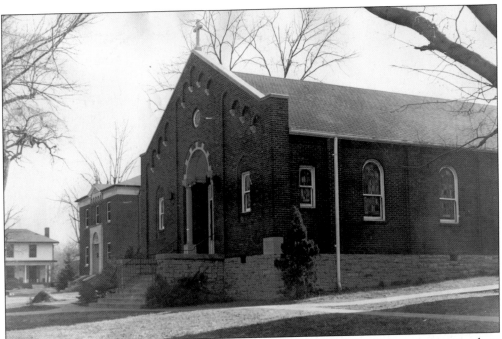

This is the new St. Ann's rectory as it looked in 1947. Note the house across the street, where Sadler Automotive is now located. (Courtesy of St. Ann's Catholic Church.)

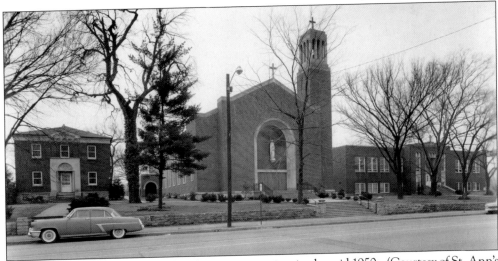

Photographed is St. Ann's chapel and rectory some time in the mid-1950s. (Courtesy of St. Ann's Catholic Church.)

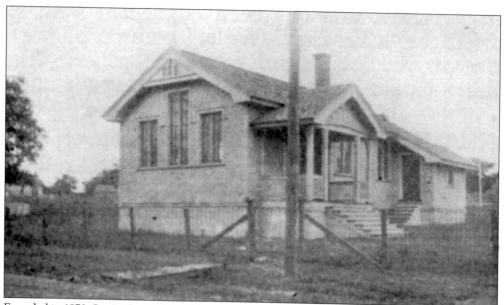

Founded in 1879, St. Andrew's Church held its first services in the old railroad depot on Charlotte Pike until its first chapel was built at Forty-seventh and Georgia Avenues in 1892. That structure was destroyed by a tornado in 1893. After rebuilding, it was burned down by a lightning strike in 1896. Wisely choosing a new location, the congregation built the current structure in 1902 at Forty-ninth and Michigan Avenues.

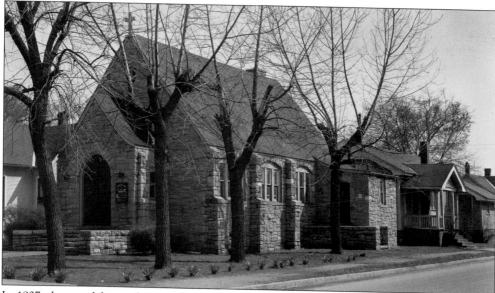

In 1927, the wood-frame chapel at Forty-ninth and Michigan Avenues was moved on rollers to its present location at Forty-sixth and Park Avenue. In later years, a tall stone chapel was added onto the front of the church. The church is currently known as All Saints Episcopal Church. (Courtesy of Metro Archives.)

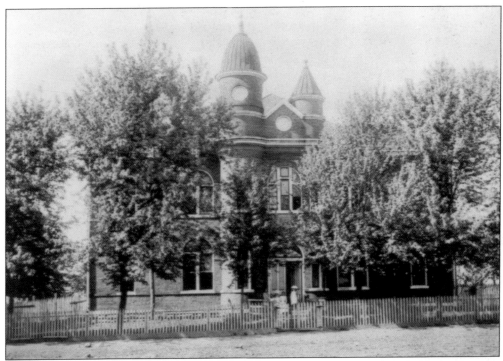

The bricks, windows, and school bell used to build West Nashville High School in 1888 were later used to build the Southern Methodist Church at the corner of Forty-fifth and Colorado Avenues. The school was constructed on Indiana Avenue through the efforts of Capt. Mark Sterling Cockrill. West Nashville High School was dismantled in 1941.

Because it recycled materials from the old West Nashville High School, total costs for the building and furnishing of Southern Methodist Church at 4409 Colorado Avenue were only $6,500 by the time it was completed in 1947. (Courtesy of Jack and Marjorie Grizzard.)

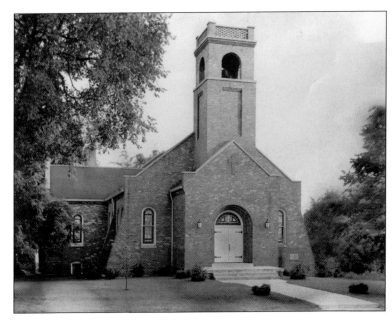

Built in 1917, the West Nashville Presbyterian Church at 4608 Charlotte Pike was organized by Capt. Mark Sterling Cockrill. The original building, pictured above, still faces Forty-seventh Avenue.

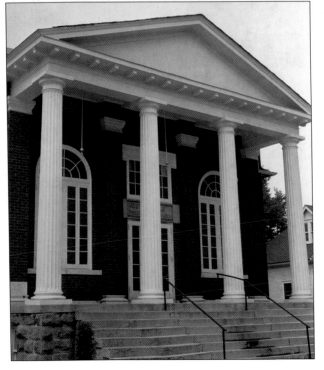

At left is the front view of the more modern four-column side of West Nashville Presbyterian Church, facing Charlotte Pike. The building is currently used as the Darkhorse Theater. (Courtesy of the Tennessee State Library and Archives.)

Six

SCHOOLS

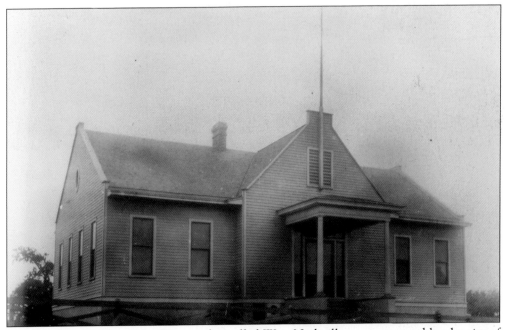

In 1907, the year after New Town—also called West Nashville—was annexed by the city of Nashville, Sylvan Park School opened in the building pictured above. An older resident of Sylvan Park remembers 25 or 30 children being taught around a potbellied stove by teacher Murray Anderson. Though the streets were named differently at the time, this two-room clapboard house faced Wyoming Avenue and was located between Forty-seventh and Forty-ninth Avenues. A "little hall" was added separate from the pictured "big hall" to accommodate more students in grades one through eight. The above picture is from the 1917 West Nashville newspaper *Modern Methods* and illustrates what a rural community West Nashville was at the time. Sylvan Park School joined the city school system in 1925. The two wooden buildings were torn down by Andrew B. Pratt in 1936, after the present brick Sylvan Park School was completed. Major additions were made to the brick school in 1944, 1950, 1953, and 2009. It was reported by old-timers from 30 years ago that to the rear of the school, where children at that time pitched horseshoes, Native Americans met and held war dances during pioneer times.

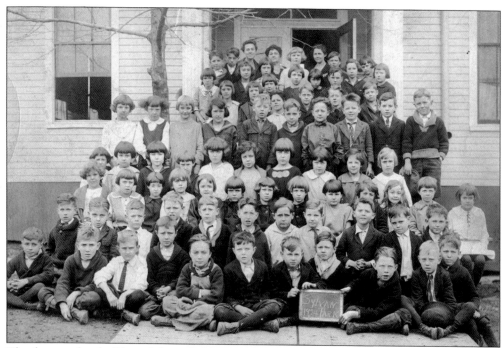

The date on the chalkboard these children are holding is 1924. This class picture was taken on the front steps of the "little hall" of Sylvan Park School. (Courtesy of Tennessee State Library and Archives.)

This is a 1924 picture of Sylvan Park fifth- and sixth-graders in front of the old "big hall." (Courtesy of Tennessee State Library and Archives.)

Elizabeth Pegram's relatives kept this picture of her second-grade class, also taken on the front steps of the old Sylvan Park School. The exact date of this photograph is uncertain. Note that some boys are wearing ties, while others are barefoot. (Courtesy of Sylvan Park School.)

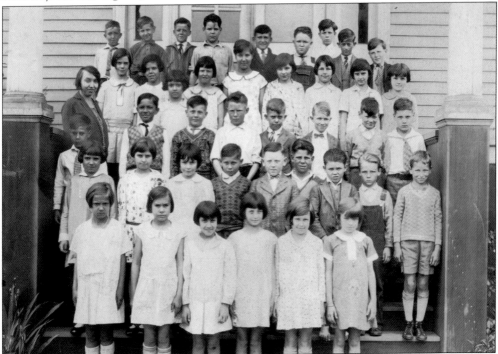

Photographed here is a class picture of fourth- and fifth-graders in 1929, also taken on the front steps of the old wood-frame Sylvan Park School. (Courtesy of Sylvan Park School.)

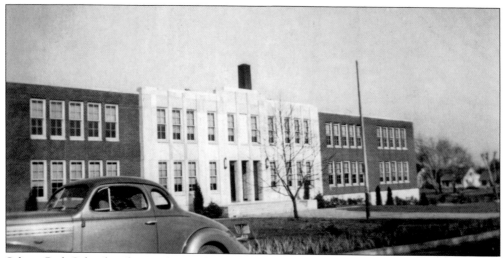

Sylvan Park School is shown above when it was a new building, probably about 1939 or 1940. (Courtesy of Sylvan Park School.)

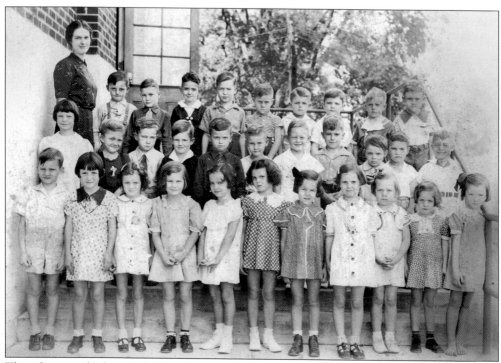

The side steps of Sylvan Park School were once a favorite place for class pictures. This photograph is from 1938. The teacher is Miss Loftis. (Courtesy of James Brazzell.)

Above is a Sylvan Park School International Day celebration in 1937. (Courtesy of Sylvan Park School.)

Who would have guessed that two legendary sweethearts-to-be were getting their pictures taken on Sylvan Park International Day in 1937? Marjorie Phelan is the flower girl on the far left of the preceding picture, and her husband-to-be, Jack Grizzard, is in another picture taken that day (above right). As this book goes to print, they have been married for 60 years. Both were born in Sylvan Park homes, less than 10 blocks away from each other. (Left, courtesy of Sylvan Park School; right, courtesy of Bud Campbell.)

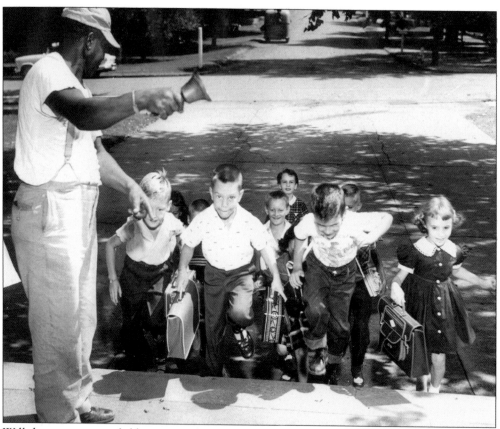

Will the janitor rings children into Sylvan Park School on a 1955 morning. (Courtesy of Connie Sadler Putman.)

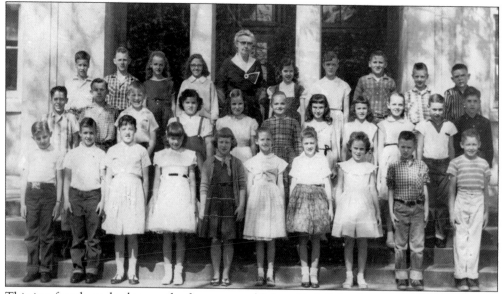

This is a fourth-grade class on the front steps of Sylvan Park School in 1958. The back of the picture says "Juanita, 9 years old." (Courtesy of Sylvan Park School.)

This photograph, from around 1960, shows a field trip during which Sylvan Park School third-graders visited the fire hall with Nashville fire chief and Sylvan Park resident John Ragsdale. Chief Ragsdale retired in 1963. (Courtesy of Connie Sadler Putman.)

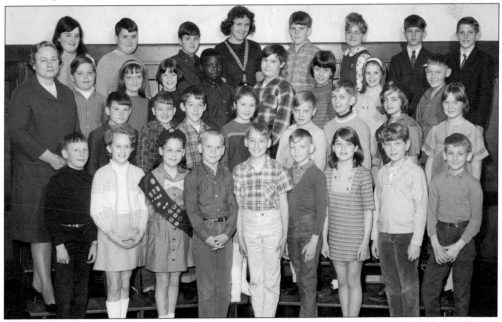

In later years, indoor class pictures offered better control of the lighting. Coauthor Yvonne Eaves is the Girl Scout on the second row, second from right, in this 1967 picture of a fifth-grade Sylvan Park School class. (Courtesy of Sandra Bailey Vaught.)

Few Nashville educators were as revered as Prof. Jonas H. Sikes, known during his lifetime as "the Grand Old Man of Nashville." Born in Shelbyville, Tennessee, in 1859, he started his career as a Nashville educator in 1896. A strong advocate of sports, he organized the first girl's basketball team in Nashville in 1905. He served as Cohn School principal from 1928 to 1939, retiring the first year that the school graduated a senior class. It is uncertain why the Cohn High School football field that is named for him, as well as other records of the period, spell his last name "Sykes." William R. Rochelle was his assistant principal for two years and succeeded him as Cohn High School principal.

Pictured speaking over the intercom to his Cohn High School students is principal William R. Rochelle. Small of stature but large of presence, he was a graduate of a military academy and George Peabody College for Teachers. Born in 1904 and the son of a principal, he became head of a rural junior high school at age 20 and was principal of Cohn School from 1937 to 1965. He and his wife, Mary, were very active in working with the developmentally disabled and in 1968 began the foundation that funded the Rochelle Center. At various times in his career, Rochelle coached football, basketball, baseball, and track, and he was fond of writing poetry. (Courtesy of the Tennessee State Library and Archives.)

Cohn High School was named after board of education member Corinne Lieberman Cohn (1866–1928). Her passion was junior high schools, resulting in the school opening the year after her death. A 10th grade was added in 1936, along with a new wing that doubled the size of the building. The 11th and 12th grades were added in 1937 and 1938, respectively. Cohn's husband, Charles, attended PTA meetings, events, and graduation ceremonies long after the death of his wife and in his will granted thousands of dollars to maintaining the library at a top level.

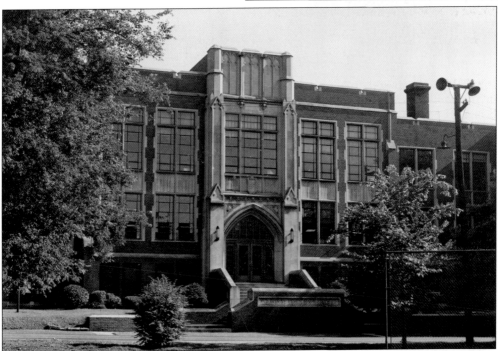

Additional construction in 1949 nearly doubled the size of Cohn High School again, and a girls' gym was added in 1969. Even with the expansion, Richland Park needed to be used for outdoor physical education classes. The school's football field was located nearly a mile away, today on the other side of Interstate 40. This photograph was taken around 1945. (Courtesy of Donald Harris.)

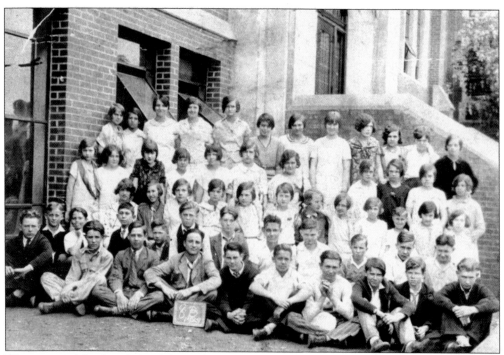

This is one of the first Cohn School classes in 1929. W. D. Crannor was the teacher. (Courtesy of the Tennessee State Library and Archives.)

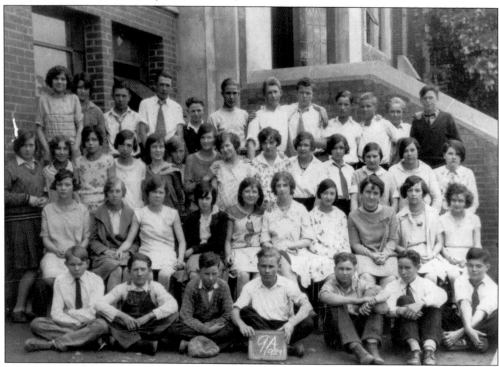

Above is a ninth-grade class from Cohn Junior High in 1929. (Courtesy of Cohn High Alumni Association.)

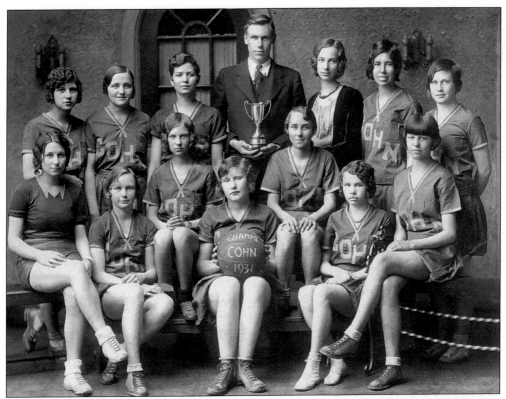

A young W. H. "Pop" Brown poses with the 1931 girls' basketball team that won the city championship. Still coaching in 1966, Pop coached a wide variety of winning sports teams. (Courtesy of Connie Putman Sadler.)

The teacher looks on indulgently as young members of the woodworking class pose ominously for the camera with their wooden daggers, probably in the late 1930s. (Courtesy of Cohn High School Alumni Association.)

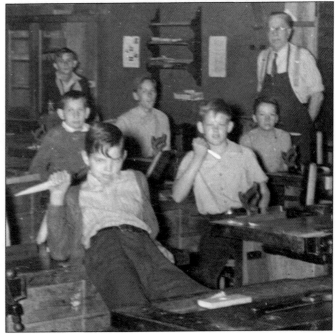

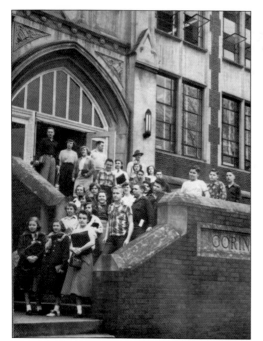

From 1928 to 1983, more than 6,000 students graduated from Cohn High School. These two pictures are from 1952. (Both, courtesy of Cohn High School Alumni Association.)

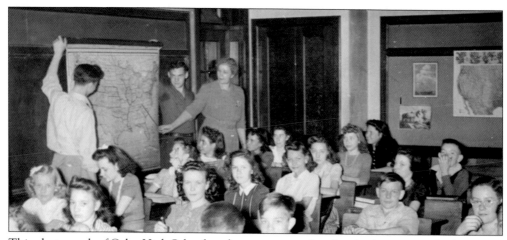

This photograph of Cohn High School students appears to be of underclassmen in the late 1930s or early 1940s. (Courtesy of Cohn High School Alumni Association.)

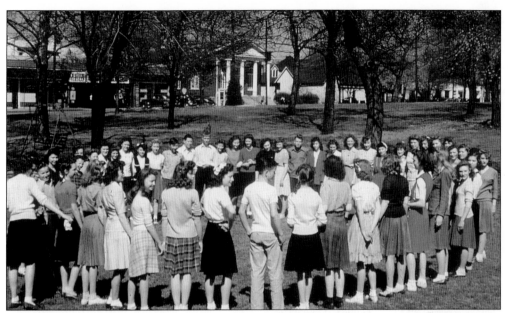

Richland Park was the outside grounds for Cohn School. Here students gather at lunchtime in the late 1940s. (Courtesy of Ed Crump.)

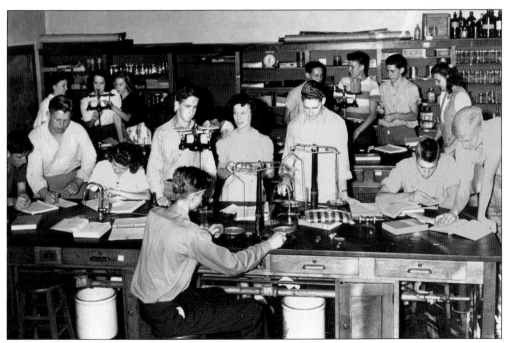

Students stay active in the Cohn High School chemistry lab in the late 1940s. (Courtesy of Cohn High School Alumni Association.)

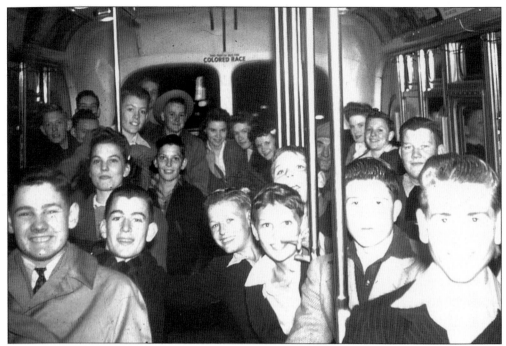

All set to enjoy a field trip, these Cohn High School students from the late 1940s unwittingly pose in front of a back-of-the-bus reminder of the times they lived in. Cohn High School was officially desegregated in 1965, but it was five more years before the first African Americans were incorporated into the school's faculty, according to the 1970 school history, *Up the Stairsteps of Cohn High School*. (Courtesy of Ed Crump.)

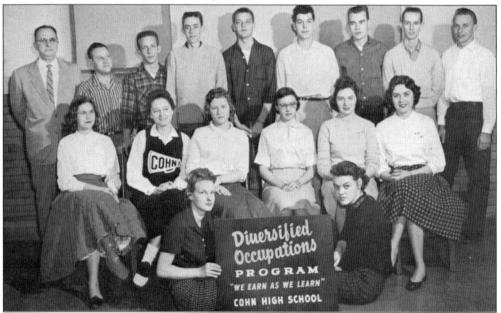

Cohn High School was one of the first schools in 1940 to initiate a vocational education program that provided both instruction and real-world participation in blue-collar jobs of interest. The above photograph is from 1958. (Courtesy of Cohn High School Alumni Association.)

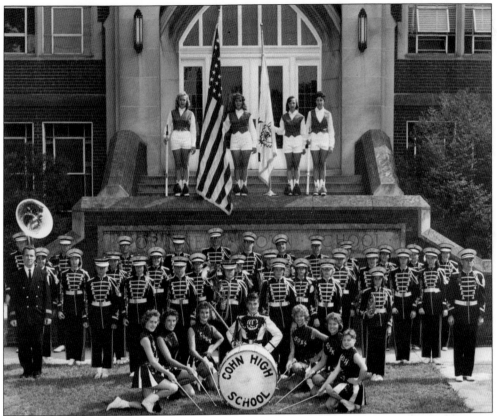

Pictured is the 1964 Cohn High School Marching Band. To herald Friday night home games, the marching band paraded down Forty-eighth Avenue to Sykes Field. The sound of the beating drums was heard throughout West Nashville and helped attract fans to the game. (Courtesy of Cohn High School Alumni Association.)

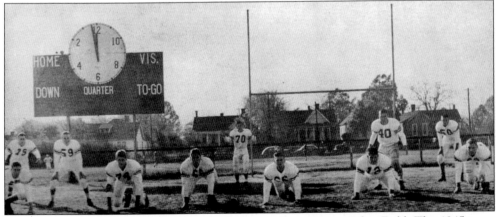

Members of the 1953 Cohn High football team strike poses on Sykes Field. The 1945 team had a dramatic 99-yard return of a recovered fumble for a winning touchdown against nearby West End High School. It was Cohn's first win ever against their archrival. Cohn High School football teams went on to lose only one game from 1945 to 1947. (Courtesy of Cohn High School Alumni Association.)

Above is the eighth-grade graduating class of St. Ann's Catholic School in 1935. The school's first classes began with 48 children in September 1921. The next year, 10 more students attended, and by 1937, there were 93 students in grades one through eight. (Courtesy of St. Ann's Catholic Church.)

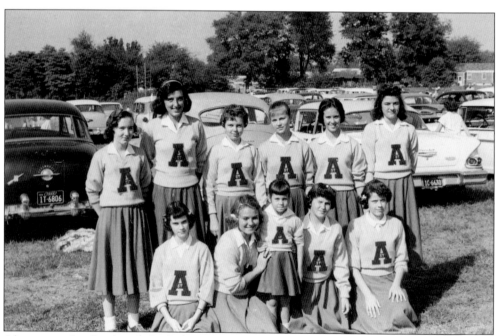

Above are the St. Ann's Catholic School cheerleaders in 1959. (Courtesy of St. Ann's Catholic Church.)

Seven

TRANSPORTATION

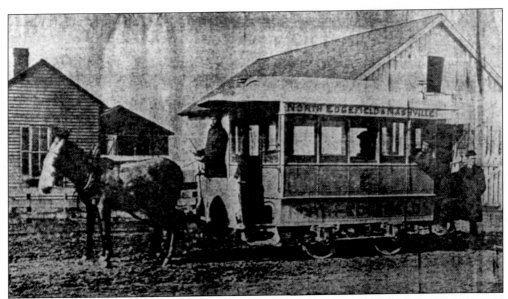

Mule-drawn streetcars were the prevalent mode of mass transportation for Nashville from 1865 until 1889, when the first electric streetcars were introduced locally. The above picture is from the east Nashville neighborhood of Edgefield around 1885, but the west Nashville streetcars looked much the same.

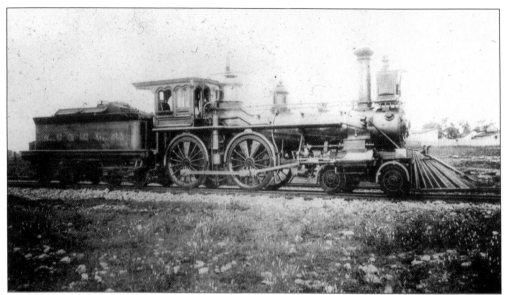

In 1895, six years after the first electric-powered streetcar was introduced in Nashville, a steam-powered small-gauge railway "dummy line"—a term used to indicate a single-terminus train—pulled passenger cars back and forth between Nashville and the area that would become West Nashville and Sylvan Park. The dummy line was run by Lemuel H. Davis, president of the Richland Railway. It looked very similar to the Nashville, Chattanooga, and St. Louis Railway's engine, the *Tennessee*, which is pictured here.

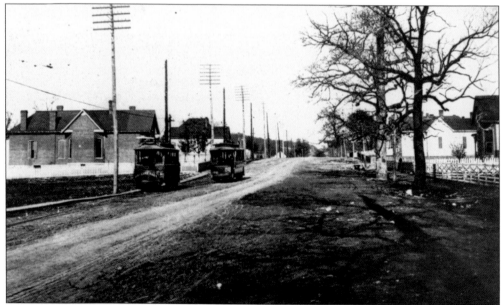

Streetcars are the form of transportation that made it possible to develop Sylvan Park into a residential area. Above is a view down Charlotte Pike around 1900. One historian wrote in the 1968 West Nashville business directory that West Nashville residents of 1913 still believed they were somewhat falsely convinced to support the area's annexation by the city of Nashville in 1906 for a promise of "5¢ transportation to the heart of the city for 100 years." What official supposedly made this promise was not explained.

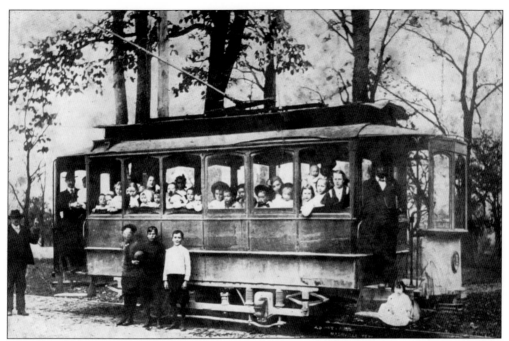

Around 1905, a small streetcar—dubbed "the Dinky"—ran along present Forty-sixth Avenue from Murphy Road to Charlotte Pike. Its only purpose was to transport residents up to the main streetcar line on Charlotte Pike.

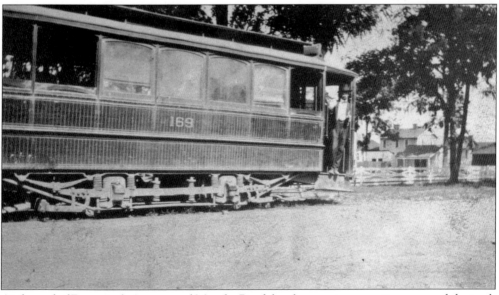

At the end of Forty-sixth Avenue and Murphy Road, local youngsters sometimes greased the track so the Dinky would spin its wheels trying to make it up the small elevation from Murphy Road to Charlotte Pike. The trolley operators sometimes had to call Public Works for a tow by mule. When the trolley employees started using sand to foil the greasers, some local boys managed to tow a telephone pole across the tracks on Halloween!

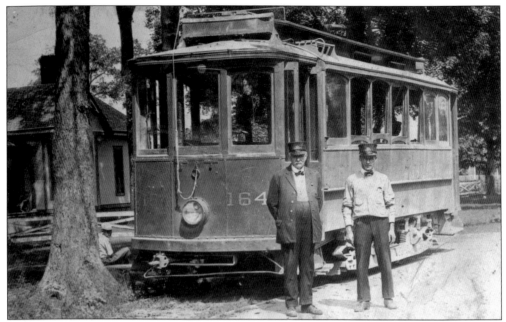

The Dinky was operated by Andrew Johnson Wrather, left, and George Booth, right. Not only did they have to watch out for greased tracks, they also had to be on the alert for street skaters, wagon coasters, and kids trying to hitch a ride by hanging on to the trolley as they rode their bicycles.

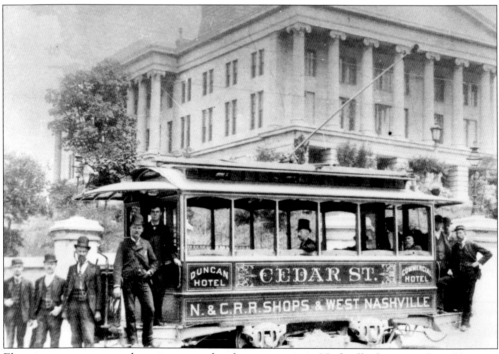

Electric streetcars were the primary mode of mass transit in Nashville for more than 50 years, from 1889 until 1943. This photograph shows the streetcar that ran between the state capitol and West Nashville. (Courtesy Nashville Public Library, the Nashville Room.)

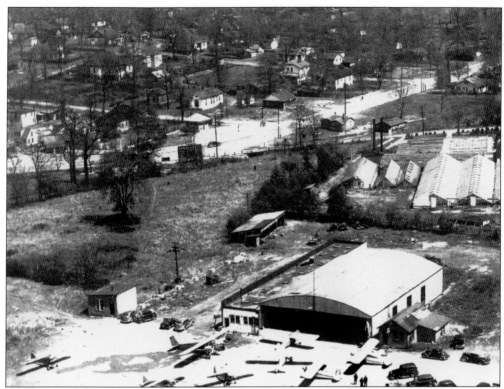

McConnell Field was Nashville's first municipal airport, reportedly built close to the city to speed airmail communications. Here is an aerial view of McConnell Field in 1933. Note the greenhouses of Geny's Flowers in the middle right of the picture and the period cars at the bottom right. (Courtesy of John Dean.)

At right is another aerial view of the area, possibly before 1933. It is difficult to distinguish details because the deterioration of the photograph and the snow on the ground change the contrast. McConnell Field operated from 1927 to 1937, when Berry Field opened on the site of the current Nashville airport. (Courtesy of John Dean.)

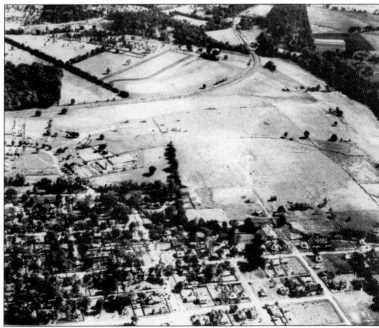

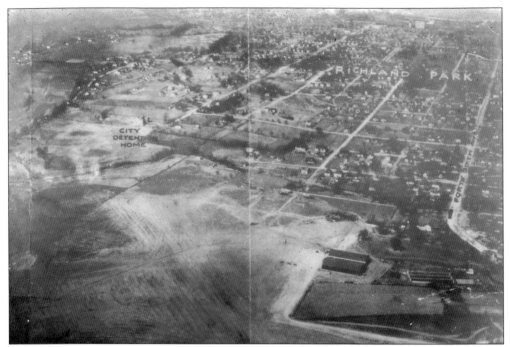

This aerial view of McConnell Field shows the hangars in the bottom right and the relatively rural and open nature of the Sylvan Park neighborhood at the time, most likely the early 1930s.

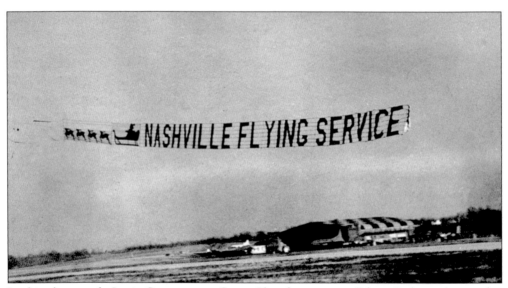

In this photograph, Louie Gasser tows a Santa Claus banner over Sylvan Park to advertise his McConnell Field flying service.

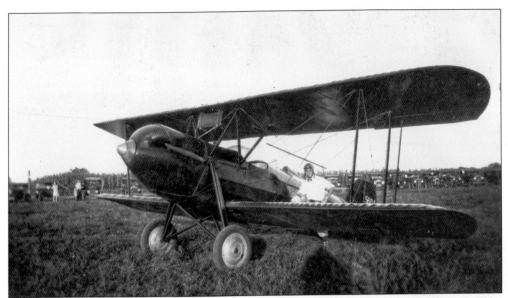

Sylvan Park children flocked to McConnell Field to watch the airplanes. Pictured is one of the biplanes flown from McConnell Field in the early 1930s.

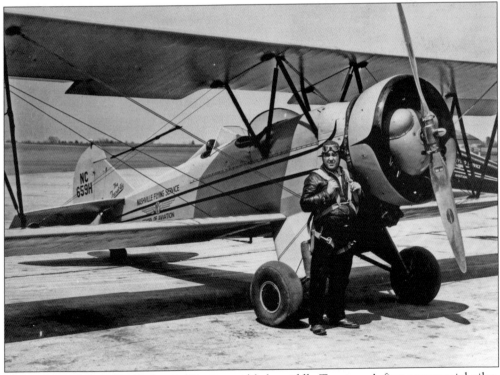

Shown here, Sylvan Park's Louie Gasser was likely middle Tennessee's first commercial pilot. He was an instructor of aviation cadets during World War I and taught more than 500 people how to fly. With his brother, Albert, he owned and operated Gasser Harness and Saddlery and Gasser's Aerial Banners.

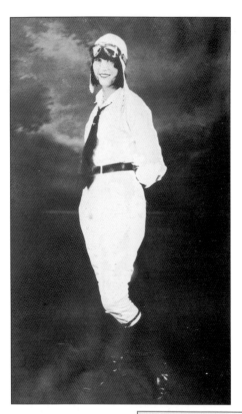

Born in 1909 in Woodbury, Tennessee, and educated through the eighth grade in a one-room school there, Nora Lee Davenport came to Nashville to work as a clipper at Werthan Bag Company. She was 17 when she met Louie Gasser at Club Dreamland on Murfreesboro Road. Gasser was a daredevil whose life was probably saved when his father took an ax to a plane Gasser had built as a boy using a motorcycle engine. Davenport felt the need to impress Gasser and chose wing walking as a way to do it. This posed photograph of a winsome young Davenport as an aviator is a charmer.

Here is a 1928 photograph of Nora Lee Davenport at McConnell Field; she was reportedly one of the first women in the South to ride a motorcycle. She drove it through flaming walls as part of a daredevil act. Louie Gasser added the motorcycle and car acts because he was unable to limit aerial stunts to 25¢-paying customers.

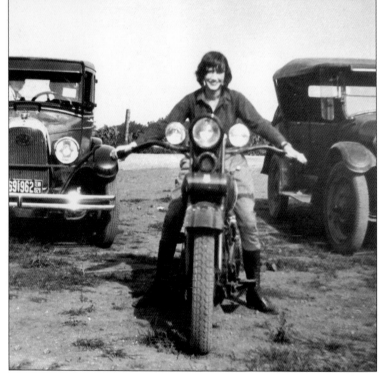

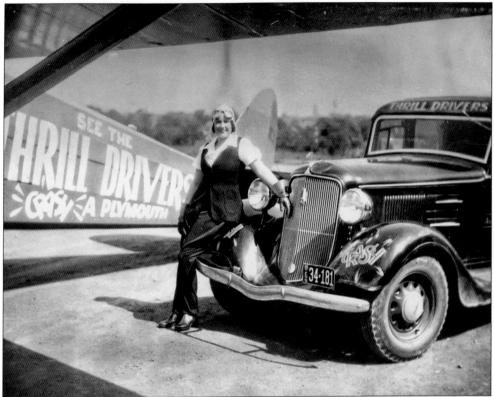

Nora Lee Davenport and Louie Gasser married, and they entertained crowds for seven years. Davenport performed more than 100 wing walks and flaming-wall crashes before Nora hung up her goggles to raise three children. During one flaming-wall car crash, two boards came through the windshield, clipped her goggles, and knocked her senseless. She came to as Gasser was patting out her flaming clothes. Despite her daredevil ways, she lived to be a 93-year-old grandmother.

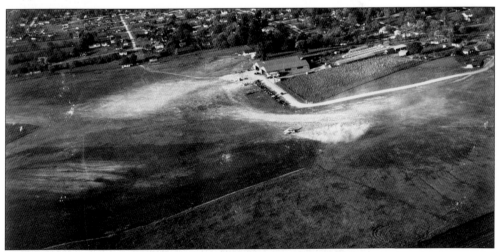

The above McConnell Field photograph, dated July 12, 1931, shows an airplane landing in the middle of the picture and the railroad line at bottom right. The Sylvan Park neighborhood can be seen along the top. (Courtesy of Metro Archives.)

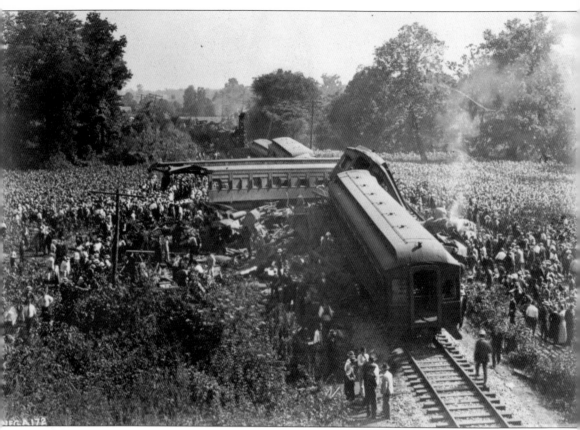

Although there was an immediate outcry for blame, it appears more than one person was at fault when two trains hurtled full-speed into each other on a blind curve known as Dutchman's Bend, located at the edge of Sylvan Park. The tragedy happened at 7:10 a.m. on July 7, 1918. The train heading west from Nashville had the responsibility for watching for the eastbound train coming in from Memphis before getting on the stretch of shared track, but its conductor, engineer, porter, and switchman all failed in that duty. The death count was first reported at 121, then was estimated at more than 200, and was finally set by regulatory authorities at 101. The *Tennessean* newspaper listed 86 names of the deceased and counted 41 more bodies as unidentifiable. Though the numbers were disputed, the carnage at the scene of this accident was inarguably ghastly.

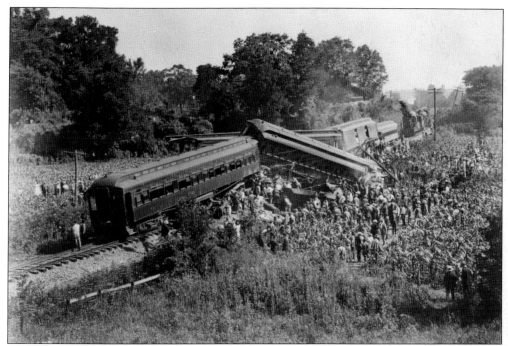

The urgency of wartime shipments meant the track needed to be cleared for use as soon as possible, and legal liabilities do not appear to have been a consideration at the time. Sightseers found themselves requested to help. By 10 p.m., the track was cleared enough to use, but for days afterwards, crews recovered parts and pieces and even buried some remains near the track.

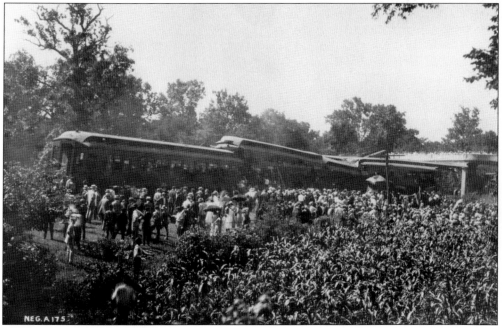

The number of gawkers who arrived at the accident scene was estimated between 30,000 and 50,000, making it difficult in some photographs to distinguish the people from the sheaves of corn in the surrounding fields. (Courtesy the Nashville Public Library, the Nashville Room.)

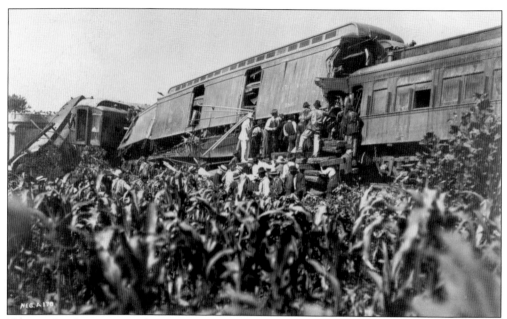

Note in the above picture that one car telescoped completely through the other, forcing the walls of that car outward and leaving no apparent room for survivors.

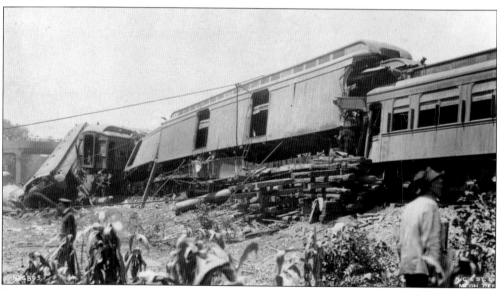

Here is a closer view of the railcars pressed through each other. Wooden beams were stacked for supports, and a jack lift is shown under the corner of the car. Note also the cables being used to stabilize the wreckage.

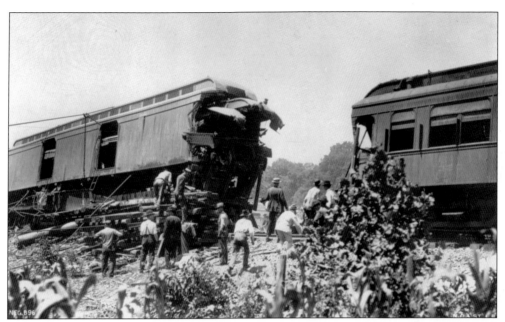

In the above photograph, workers managed to separate two of the cars, but one or more are still inside each other.

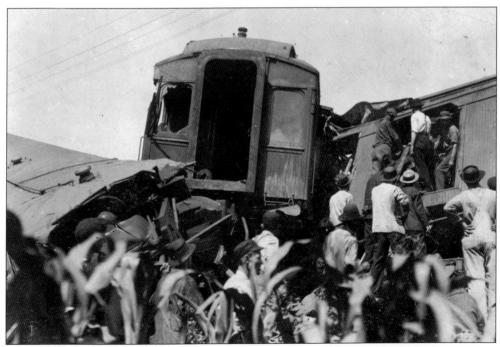

The heavy steel sleeper cars to the rear of the eastbound train caused the most deaths, telescoping completely through the wooden baggage cars in front of them—where African American laborers rode—like a piston through a cylinder; only those who somehow got out of the way survived. The "business end" of the steel car as it telescoped through the baggage car looked like this. (Courtesy the Nashville Public Library, the Nashville Room.)

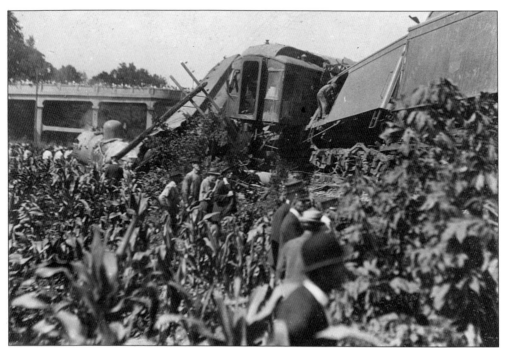

The old White Bridge Road Bridge, in the background of this photograph, still exists today. Tumbled wreckage extended from that bridge toward Nashville over Richland Creek. (Courtesy the Nashville Public Library, the Nashville Room.)

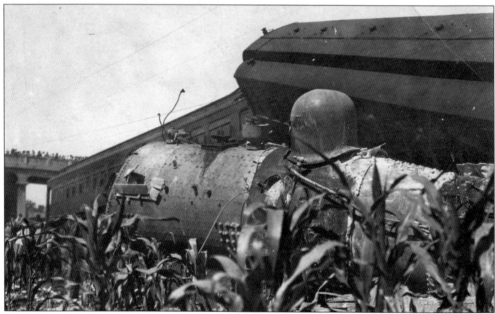

The pressured steam boiler tanks that provided the power for the two locomotives both ruptured from the deafening impact, sending shrapnel and scalding water through the air. One disconnected completely from the locomotive and bounded through the air like a screaming hot missile. In this picture, that boiler tank rests in the cornfield, separated from its moorings on the engine by quite a number of feet. (Courtesy the Nashville Public Library, the Nashville Room.)

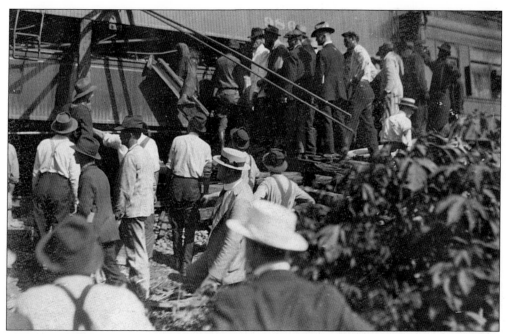

The call for help went out to all local railroad workers, more than a few of whom lived in Sylvan Park. The limbs protruding from wreckage in the mid-upper left of the photograph appear to be a victim's. (Courtesy the Nashville Public Library, the Nashville Room.)

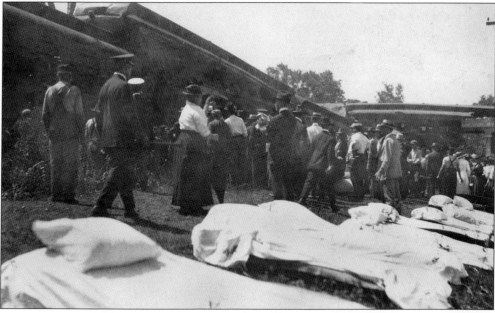

The injured and dead strained Nashville's capacity for care and evoked memories of the Civil War. Those first on the scene spent the rest of their lives dealing with their recollections of the screams and the blood. Bodies were stacked onto open wagons. Wash tubs and pails were used to collect parts, and some survivors were found buried underneath the bodies of the deceased hours after the impact. The cots in this photograph were for survivors not yet found. (Courtesy the Nashville Public Library, the Nashville Room.)

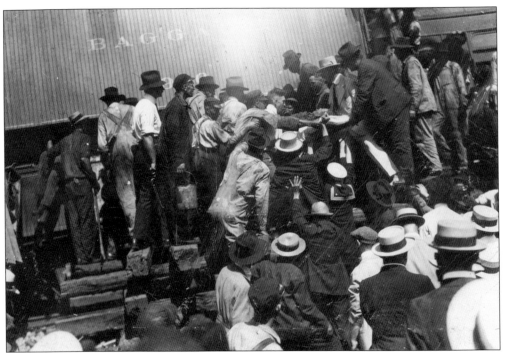

The volunteers strain forward and support each other as a survivor is pulled from the wreckage. The man in the white shirt and fedora hat to the left holds a hacksaw in his right hand. The man in front of him holds a pail. (Courtesy the Nashville Public Library, the Nashville Room.)

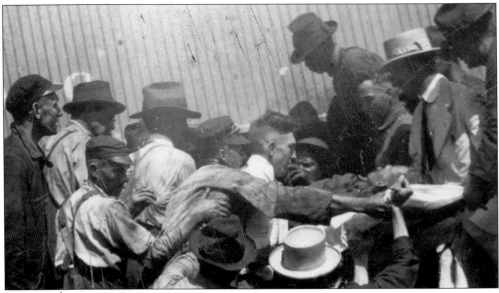

Here is a close-up of the survivor being removed from the wreckage. (Courtesy the Nashville Public Library, the Nashville Room.)

Eight

GROWING UP IN SYLVAN PARK

This picture of little Nellie Styles appears to have been taken in the front side yard of 4311 Wyoming Avenue not long after it was built in 1906. It is currently the home of coauthor Doug Eckert. Hershell Bell and his daughter kept cows, horses, and other farm animals at their home across Forty-fourth Avenue from 4311 Wyoming Avenue back when those streets were not paved. (Courtesy of the Bryant family.)

Richland Park was originally set aside as a deer park as part of the Byrd Douglas plantation grounds. As the area was developed into a residential suburb in 1887, the brush was cleared and park benches were added beneath the old-growth trees.

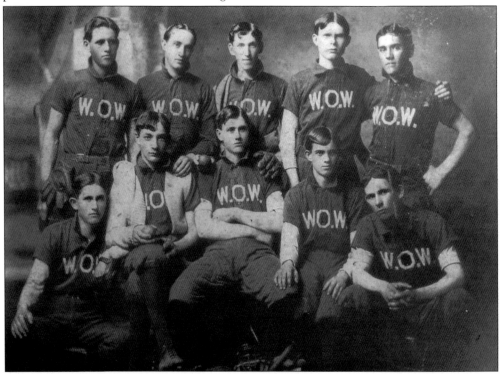

This turn-of-the-century young men's club called themselves Woodsmen of the World and held regular lodge meetings in Richland Hall. As shown above, they also fielded a baseball team that may have practiced across from Richland Hall in Richland Park.

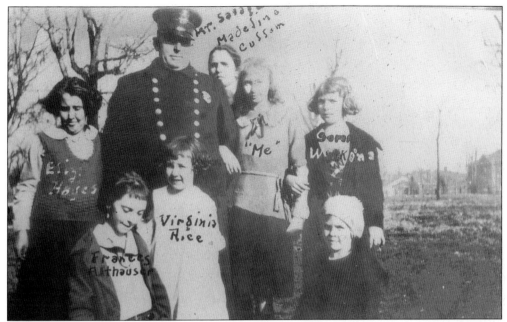

A neighborhood policeman of the early 1900s, "Officer Savage" appears charmed by a group of young girls in this Richland Park photograph. "Me" is Eva Jean Wrather, granddaughter of the Sylvan Park Dinky streetcar conductor

Mae Gillaland was a Richland Park supervisor who met with community girls for games. The Richland Park bandstand is in the background.

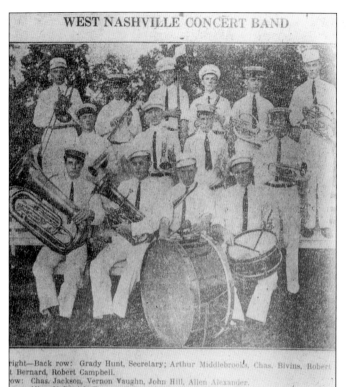

WEST NASHVILLE CONCERT BAND

The West Nashville Concert Band played regularly in Richland Park and was known for its Sunday afternoon concerts, perfectly acceptable public gatherings for young couples who were courting. One elder resident recalled "Welck, the popcorn man of Richland Park" who would give the kids a bag of popcorn if they helped carry his machine across Charlotte Pike. Another resident remembered Welck used coal oil in his popcorn machine, giving it a sooty taste.

right—Back row: Grady Hunt, Secretary; Arthur Middlebrooks, Chas. Bivins, Robert Bernard, Robert Campbell.
ow: Chas. Jackson, Vernon Vaughn, John Hill, Allen Alexander.
w: Allen McDaniel, Forrest McDaniel, President; Edwin McDaniel, Hugh Bumpas.

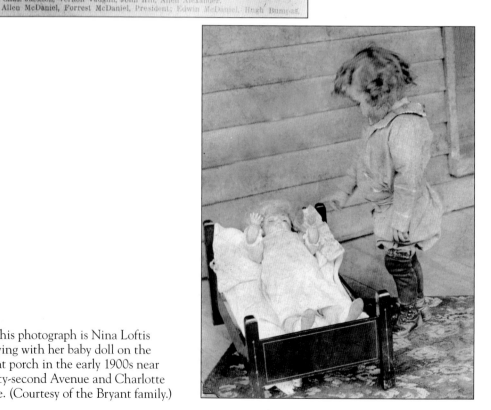

In this photograph is Nina Loftis playing with her baby doll on the front porch in the early 1900s near Forty-second Avenue and Charlotte Pike. (Courtesy of the Bryant family.)

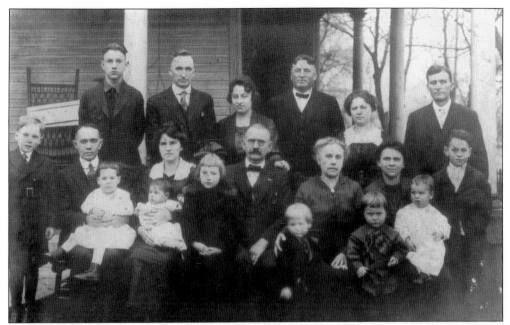

The C. W. Hooper family lived on Park Avenue near Forty-fourth Avenue. He owned and operated the Hooper Trunk Company in downtown Nashville.

Willis Farris Sr., seated above, built his home at 5100 Nevada Avenue in 1894 and founded Farris Lumber Company in 1909. Farris was killed in the 1918 train wreck at Dutchman's Curve. His son, Frank, used the insurance money from his death to help found Third National Bank.

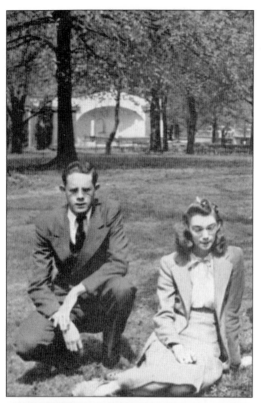

These two Cohn High School students pose in front of the old Richland Park band shell in the early 1940s. In the late 1930s, kids came to the band shell from miles around to watch free movies on Thursday nights. (Courtesy of the Cohn High School Alumni Association.)

When Richland Park Library was built in 1961, the west side of the old band shell building was kept and built onto, as seen in the change in the roofline and window style. The older crescent-top windows are part of the original band shell building, where Ping-Pong, pool, and other games were played. Regulars at these games included students from nearby Vanderbilt University. (Courtesy of the Metro Archives.)

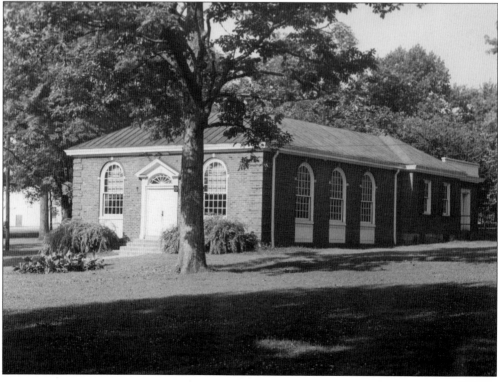

Here is a 1943 picture of some boys playing Ping-Pong inside the band shelter building that later became the children's room of the Richland Park Library. Mrs. Woolwine of the parks department had the duty of keeping order and making sure the area was shared properly. (Courtesy of the Cohn High School Alumni Association.)

It looks like a country front porch in Sylvan Park as three little Campbells sit in the sun at 5304 Nevada Avenue around 1942. From left to right are Bernadine Campbell, Nelson "Bud" Campbell, and Dwanda "Puggie" Campbell. (Courtesy of Bud Campbell.)

Friends and relatives gather at 5304 Nevada Avenue in the early 1940s. Note the card on the right post for the ice deliveryman. The number at the top told the deliveryman how many pounds of ice to leave, in this case 50 pounds. (Courtesy of Bud Campbell.)

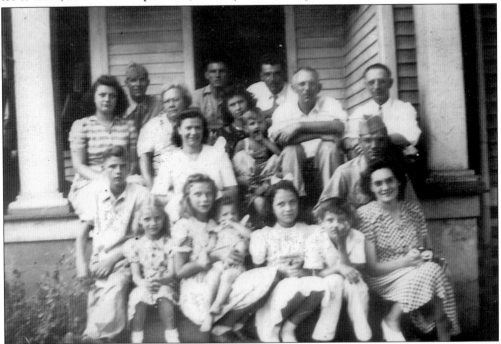

The Pickney family huddles with their children on their Sylvan Park front porch about 1943. Walter Pickney, in a serviceman's uniform on the bottom right, was severely wounded in the Battle of the Bulge in December 1944. He made a full recovery, however, sold Jewel Tea, and resided at 5202 Nevada Avenue until his death at age 92. (Courtesy of Bernard Pickney.)

These young boys, pictured in the late 1930s, are obviously enjoying themselves as they spend an afternoon on Park Avenue with Richland Park showing in the background. A longtime neighborhood resident recalled walking through Richland Park early on a dark morning as a 12-year-old paperboy, wrapping his papers as he went. Some of the old oak trees were hollow and spooky-looking, with whiskey bottles thrown in the bottom of some of them. Without a sound, the boy felt something behind him raise the hair up on his head. He turned around and couldn't see a thing. A step or two farther and it happened again. He was about to panic and run when it happened a third time and he caught a glimpse of an owl that had swooped down, probably protecting a nest in an old oak tree. (Courtesy of Ed Crump.)

These boys look ready for some neighborhood fun in the 1940s. (Careful, the boy on the far right appears armed!) Sylvan Park was close enough for boys to go downtown on the streetcar and back, but far enough out in the country for boys to skinny-dip or wrestle catfish from under rocks at Richland Creek. One resident reminisced about the time he and his young friend went to a carnival at the hay market located on Broadway and paid to see what was supposedly the body of a real-life "monster." "A woman had lost her mind and killed her husband, several children, two officers, and then killed herself. Her scary face was on a billboard outside and they had her body on the inside of the tent. We paid a quarter to see her. You could see the hairlines on her fingers. When she died she had short hair and now it was long. And her fingernails had also grown since she died. She only had a towel covering her." On their way home, the boys had to cross an undeveloped part of the neighborhood called the "commons." One boy hurried inside his front door at Fifty-third and Nevada Avenues, but the other one had to go three more blocks by himself. "He cut through Foster's cornfield. In the dark he got to stumbling, fell and ruined the new crop, got up and by the time he hit Richland Avenue he was in high gear, although he fell again in his own front yard when he got home. He could see that old woman all around him." (Courtesy of James Brazzell.)

As seen in this recent picture, Richland Creek has started to recover now from its use as a neglected dumping spot over the preceding years. The dark Greenway walking bridge is just in front of the old stone railroad bridge where the dreadful 1918 train wreck occurred. One former resident remembers Richland Creek swimming holes in this order as headed toward the river from this spot: Rail Hole (pictured), Sycamore Hole, Sheep's Hole, Cow's Hole, Buchanan's Hole, Sawmill Hole, and Whirlypool. Only one of these close to the Cumberland River was deep enough to really be a swimming hole. The others were only deep enough to sit down in and cool off. At Sheep's Hole was a 12-foot-high western bluff that kids sometimes climbed to get to an apple orchard. Getting those apples could sting, however—the owner sometimes loaded his shotgun with salt pork and fat meat to protect his crop. (Courtesy of Doug Eckert.)

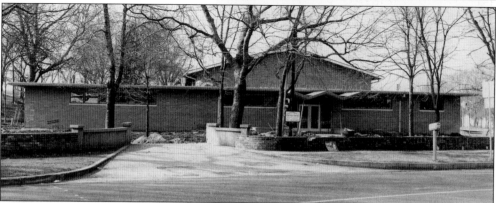

McCabe Community Center is shown above as built by the Metro Nashville Parks Department in 1960. During the writing of this book in mid-2010, this building was torn down, and the foundation was laid for a new community center. (Courtesy of Metro Archives.)

In the late 1940s, there was still a lot of free space between some of the homes in Sylvan Park. Pictured here is Nelson "Bud" Campbell (left) in front of 5302 Nevada Avenue with his friend and neighbor Ollie Ray Winfrey. (Courtesy of Bud Campbell.)

These three grown-up Sylvan Park kids are crashing a makeshift sled made out of an enamel table top at the bottom of the hill at Fifty-third and Elkins Avenue during the blizzard of 1951. All survived. (Courtesy of Bud Campbell.)

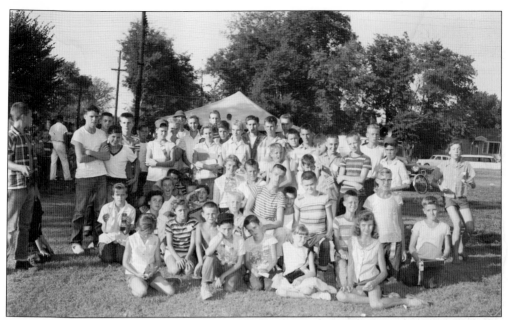

Nashville mayor Ben West organized a yearly "West Nashville Day" with youth races and other competitions for fun. Above is West Nashville Day at Richland Park in 1957. (Courtesy of Donald Harris.)

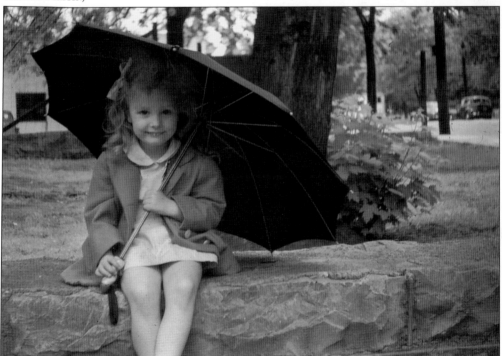

Safe from any raindrops, church musical director E. B. McDowell's daughter sits on the old rock wall next to West Nashville United Methodist Church some time around 1945. McDowell was also the music director at Cohn High School from 1943 to 1947. The authors like to imagine little miss McDowell saying "Thanks for reading!" (Courtesy of Ed Crump.)

www.arcadiapublishing.com

Discover books about the town where you grew up, the cities where your friends and families live, the town where your parents met, or even that retirement spot you've been dreaming about. Our Web site provides history lovers with exclusive deals, advanced notification about new titles, e-mail alerts of author events, and much more.

MADE IN THE USA

Arcadia Publishing, the leading local history publisher in the United States, is committed to making history accessible and meaningful through publishing books that celebrate and preserve the heritage of America's people and places. Consistent with our mission to preserve history on a local level, this book was printed in South Carolina on American-made paper and manufactured entirely in the United States.

This book carries the accredited Forest Stewardship Council (FSC) label and is printed on 100 percent FSC-certified paper. Products carrying the FSC label are independently certified to assure consumers that they come from forests that are managed to meet the social, economic, and ecological needs of present and future generations.

FSC

Mixed Sources
Product group from well-managed
forests and other controlled sources

Cert no. SW-COC-001530
www.fsc.org
© 1996 Forest Stewardship Council

Find Your Place in History.